SALTWATER COWBOYS

A PHOTOGRAPHIC ESSAY OF CHINCOTEAGUE ISLAND

Medford Taylor

"Then my mind drifted back to another time,
When the gumboot cowboys rode fast and free.
Over Assateague Island down by the sea.

These old cowboys were a special breed.
You might say one of a kind.
And every round-up they ever rode,
will be forever etched in time..."

from *The Gumboot Cowboys of Yesterday*, by Harry Clay Bunting

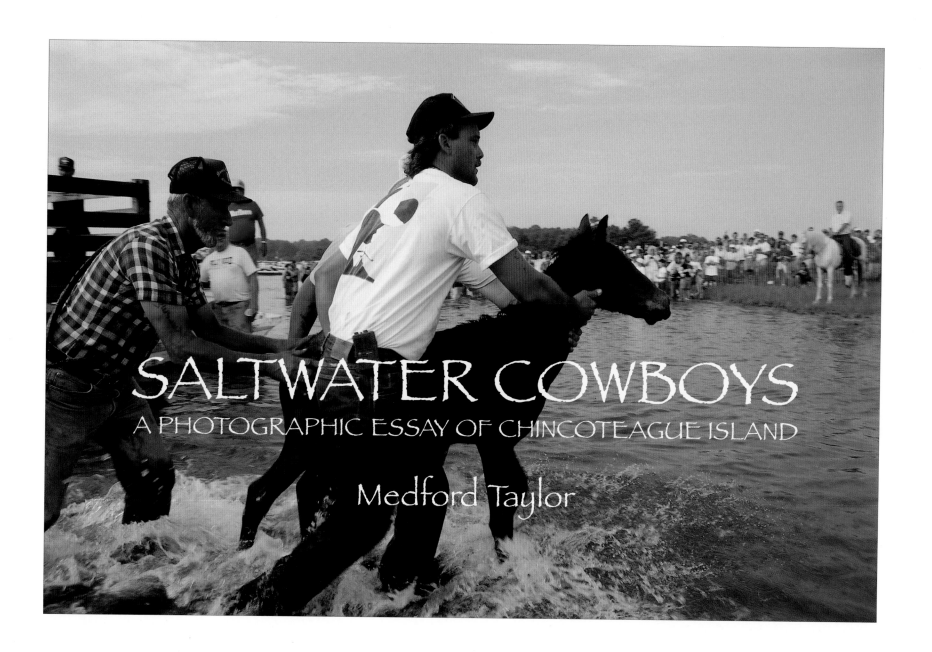

SALTWATER COWBOYS

A PHOTOGRAPHIC ESSAY OF CHINCOTEAGUE ISLAND

Medford Taylor

The headlights of a long caravan, of pickup trucks towing horse trailers, winding its way through the quiet pre-dawn streets of Chincoteague, Virginia, signal the start of the annual Pony Penning. The drivers are mechanics, watermen, farmers, firemen; a state trooper, a mayor, a teacher; but for one week, in late July of each summer, they are all 'saltwater cowboys'. By sunup the horses and riders will be splashing through the black mud of Assateague Island's saltmarshes. It is time, once again, for the wild horses of Assateague to be rounded up for the swim to Chincoteague and the auctioning of the new colts.

The small island of Chincoteague nestles in the lee of the 37 mile long barrier island of Assateague, off Maryland and Virginia's Eastern Shore. Small pine forests, scattered among the miles of saltmarshes, are bordered by the pristine shoreline of the Atlantic Ocean. In recent years Chincoteague has become a thriving vacation resort; yet it retains much of its small town charm.

Assateague is both a National Wildlife Refuge and a National Seashore. The solitude of warm summer days and the quiet splashing of great blue herons fishing their limit give way, in the fall, to the cacophony of thousands of honking snow geese returning to these nutrient-rich feeding grounds. More than a million visitors come to observe the wildlife each year, to compete with the herons for fish

and crabs, or just to relax in the warm sun and salt air of the sea.

Legend has it that the wild horses of Assateague first swam ashore from the wreck of a Spanish galleon. Today they still run wild and free, but are owned and cared for by the Chincoteague Volunteer Fire Department. From a horse-drawn pumper in 1880, to their gleaming high tech engines today, the fire department is well equipped and trained to protect the lives and property on this remote island community. Funding for the purchase and maintenance of firefighting equipment comes primarily from the auction and sale of the young colts rounded up from Assateague and from the Fireman's Carnival that is held at the same time as the annual Pony Penning.

I come here to sample the fat salty oysters, admire the beautiful bird decoy carvings and enjoy long walks on endless beaches buffered by waving fields of sea oates. I come to listen to the many sea stories spun with an Old English twang. Like a seductive mistress, these islands have drawn me back. I have acquired many dear friends here over the years and a treasure of memories. Some of these memories I was fortunate to capture on film. The photographs gathered here might best be described as a photo album of a continuing love affair. – *Medford Taylor*

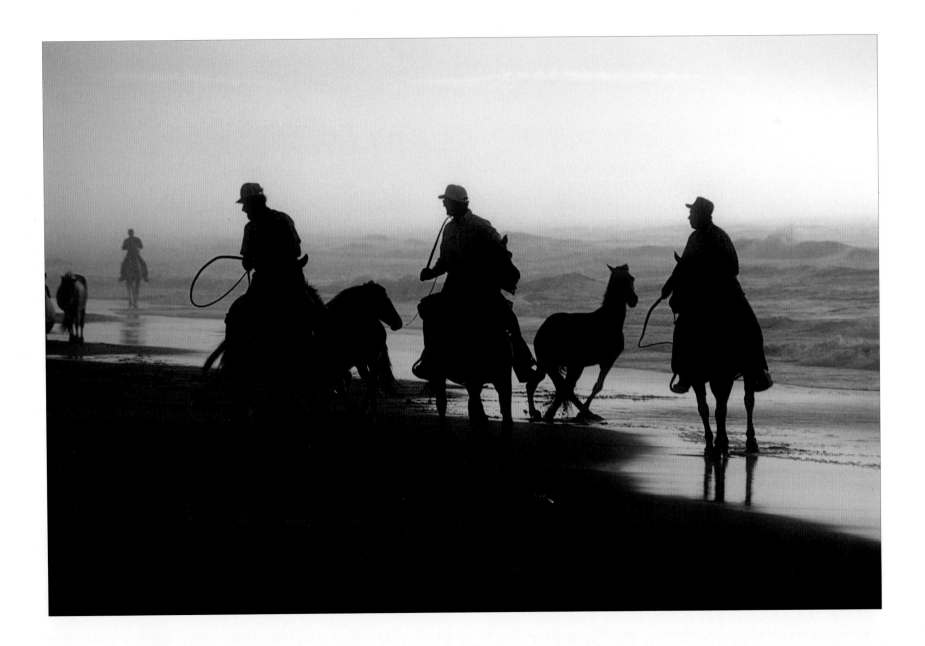

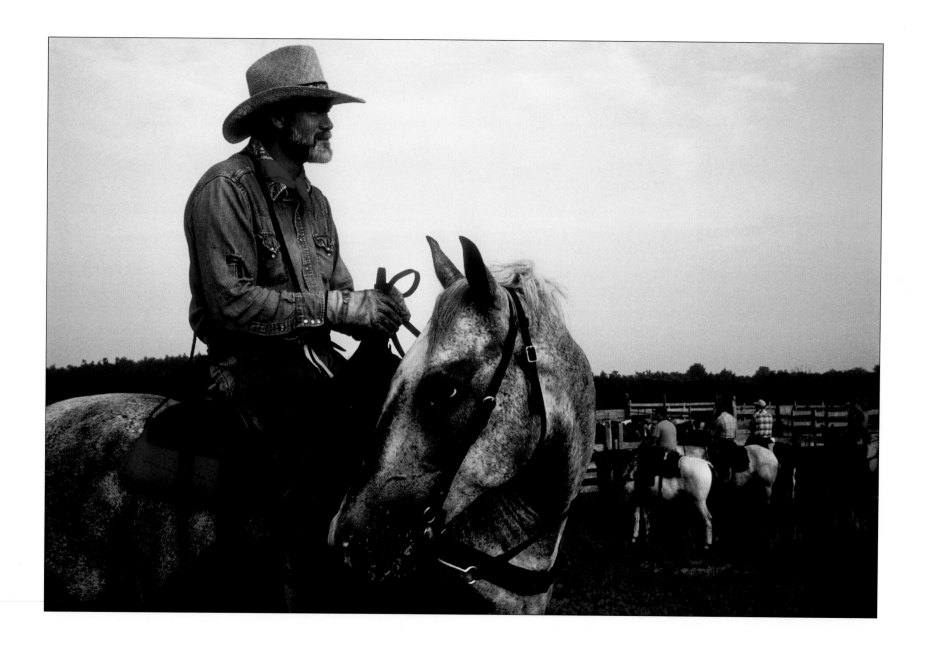

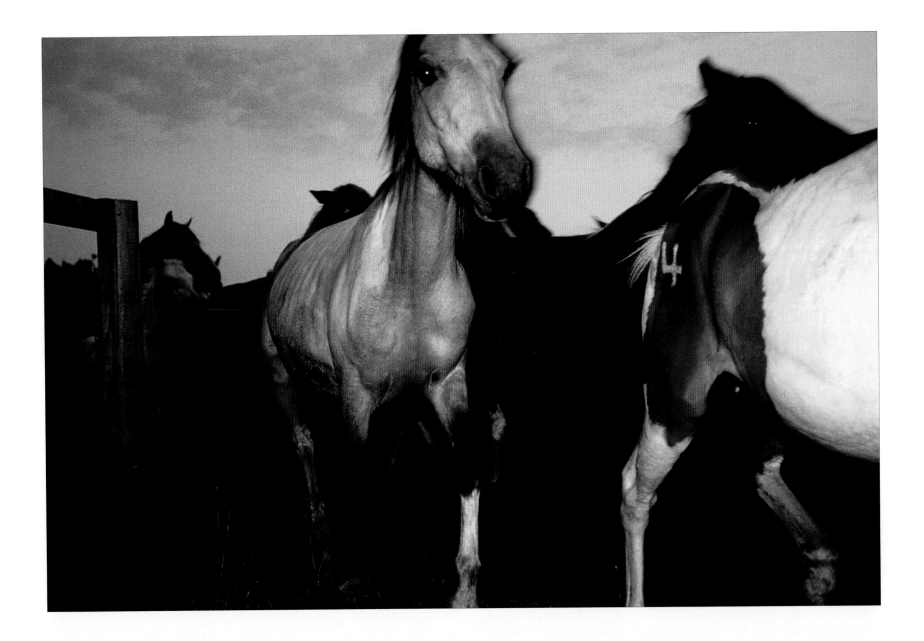

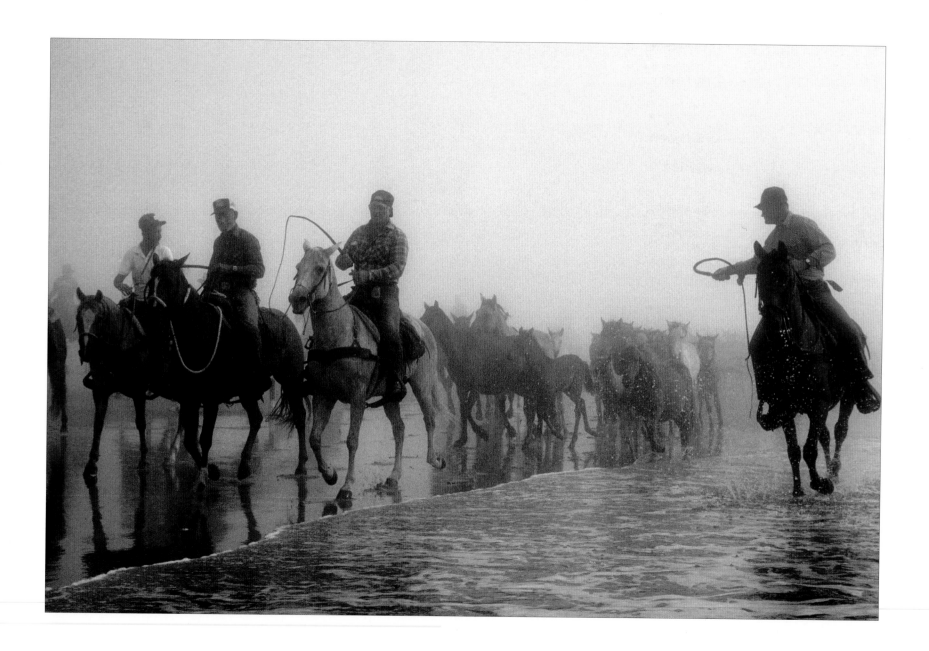

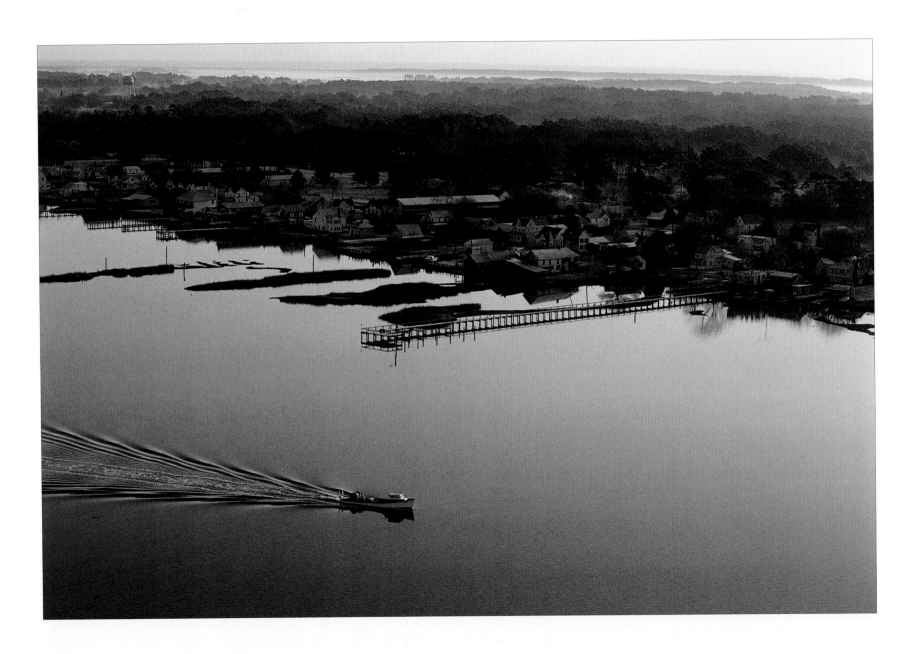

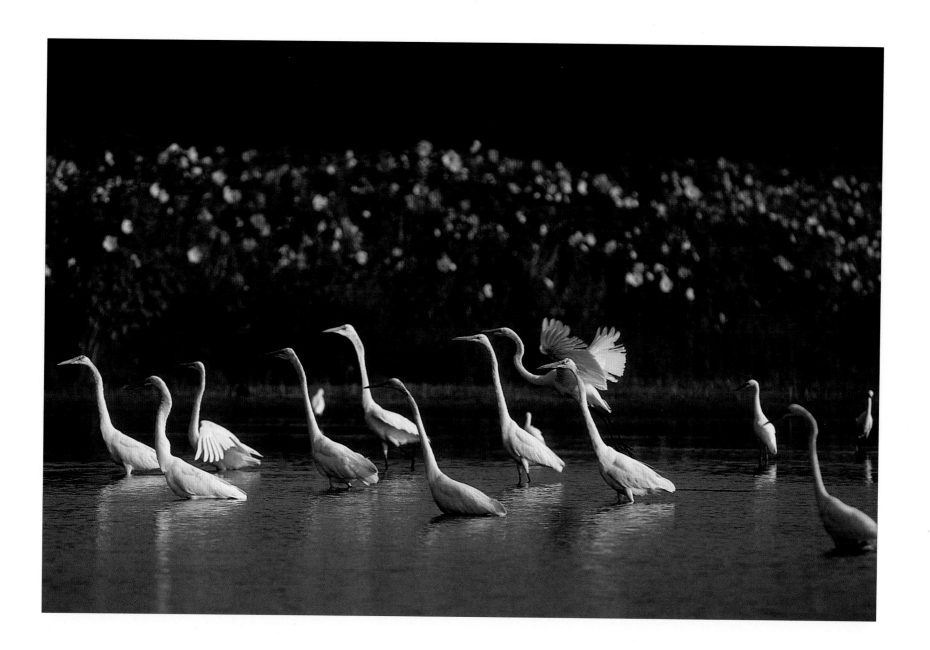

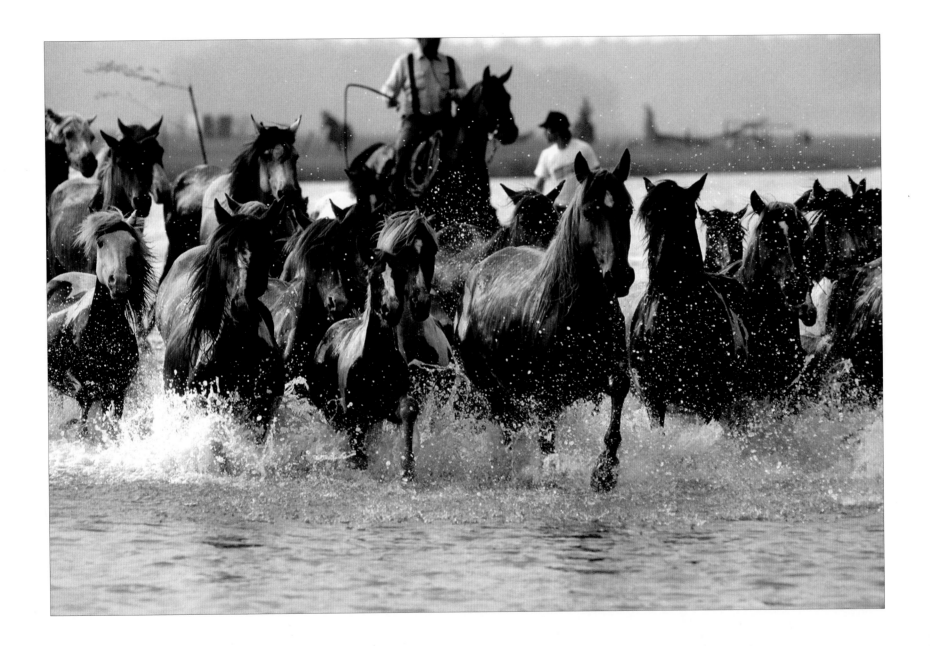

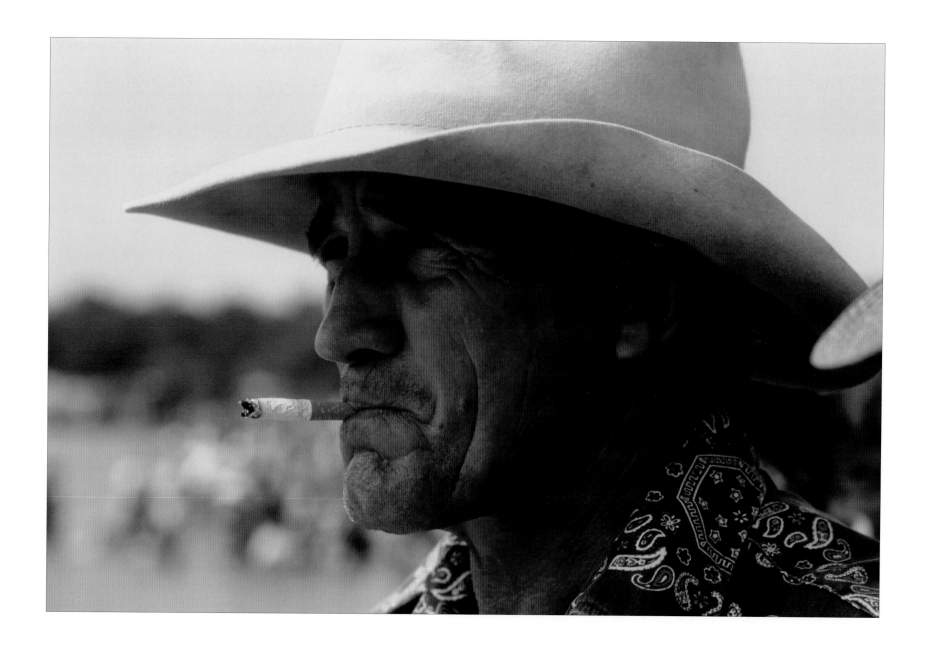

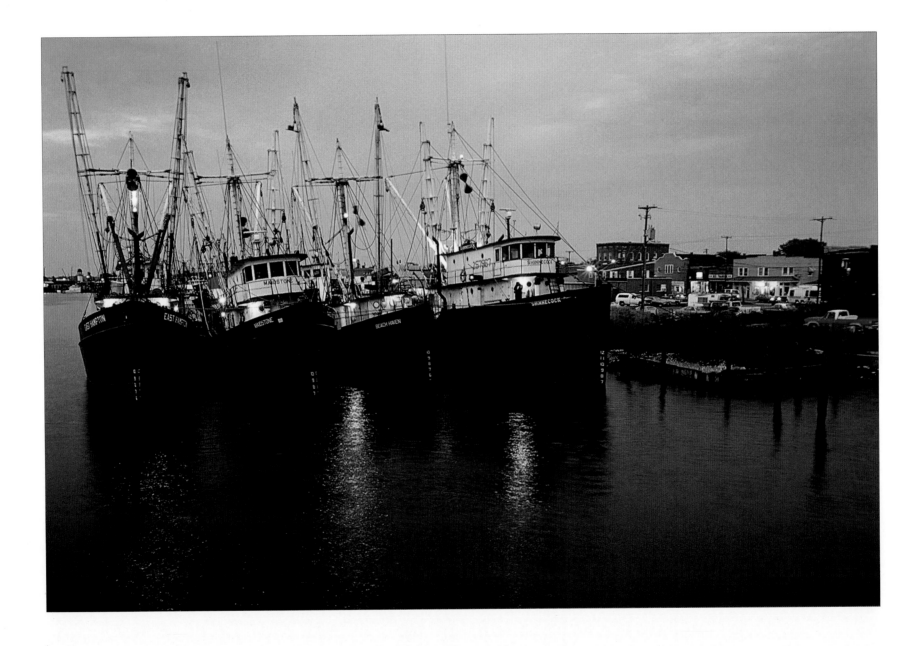

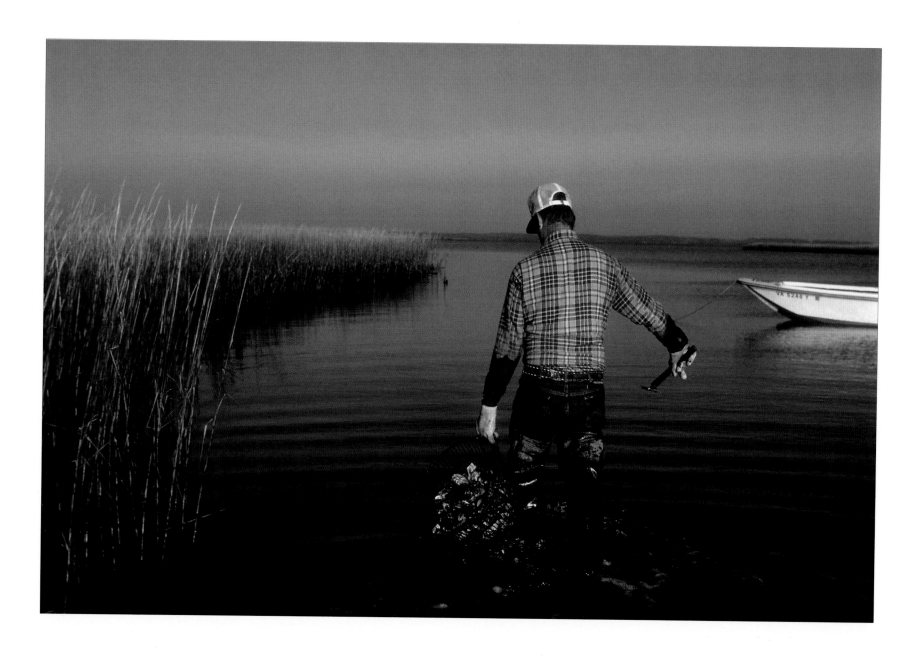

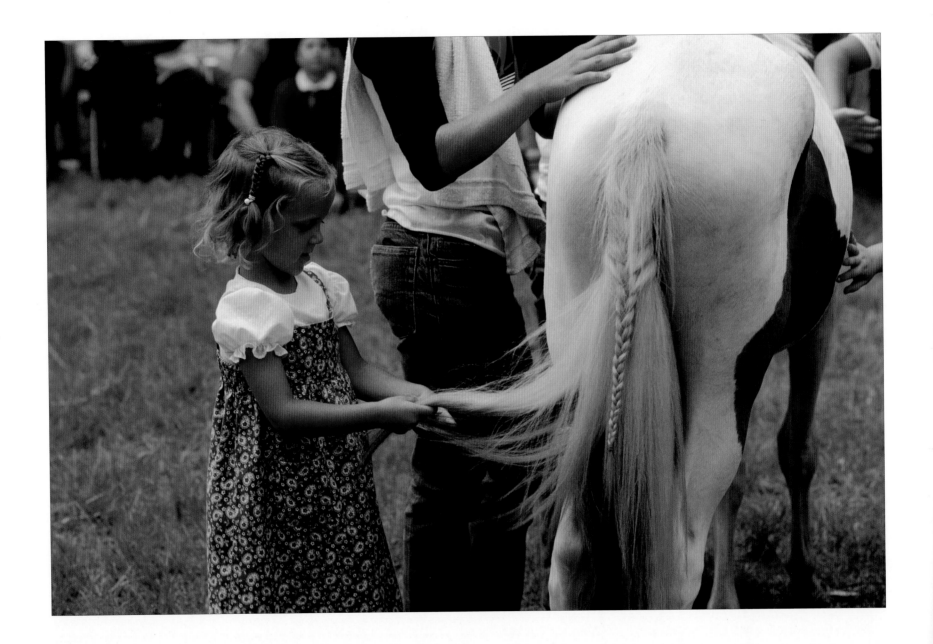

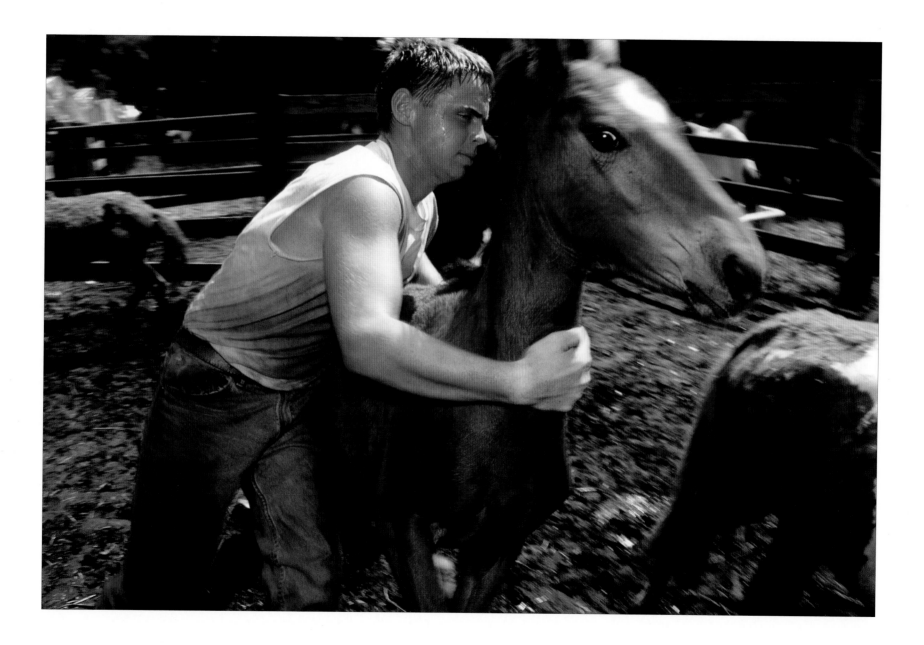

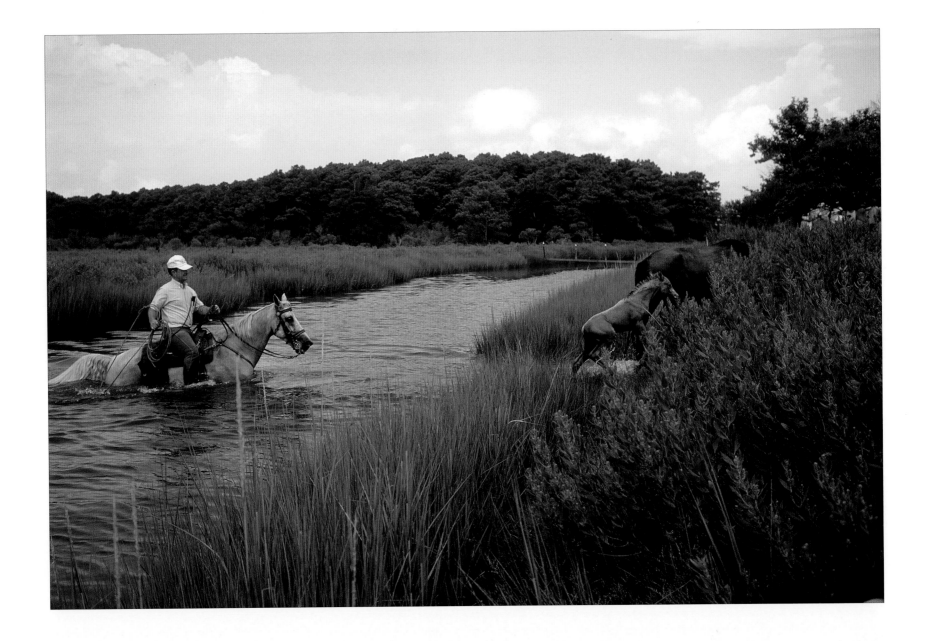

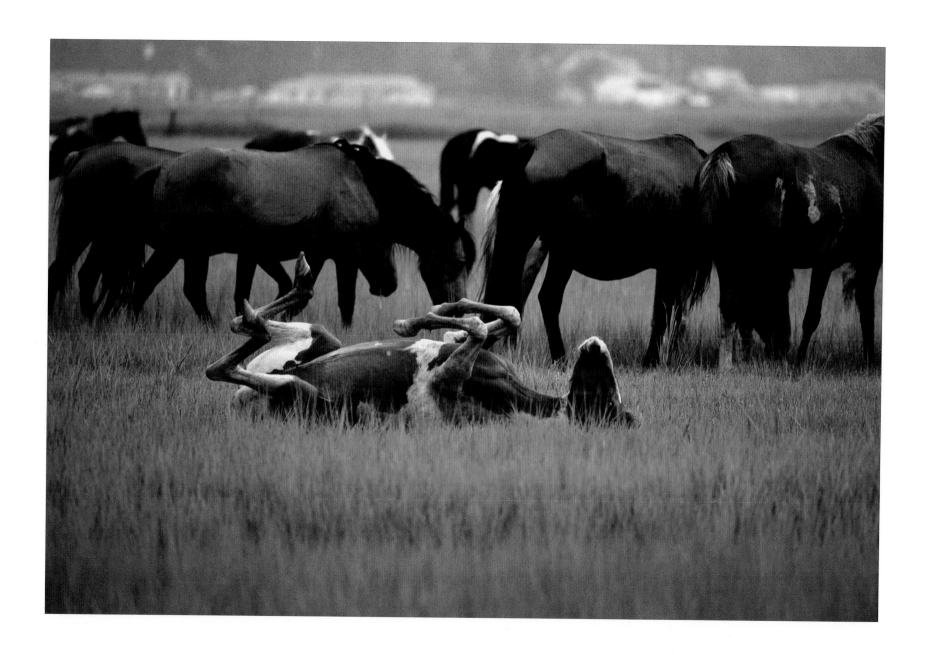

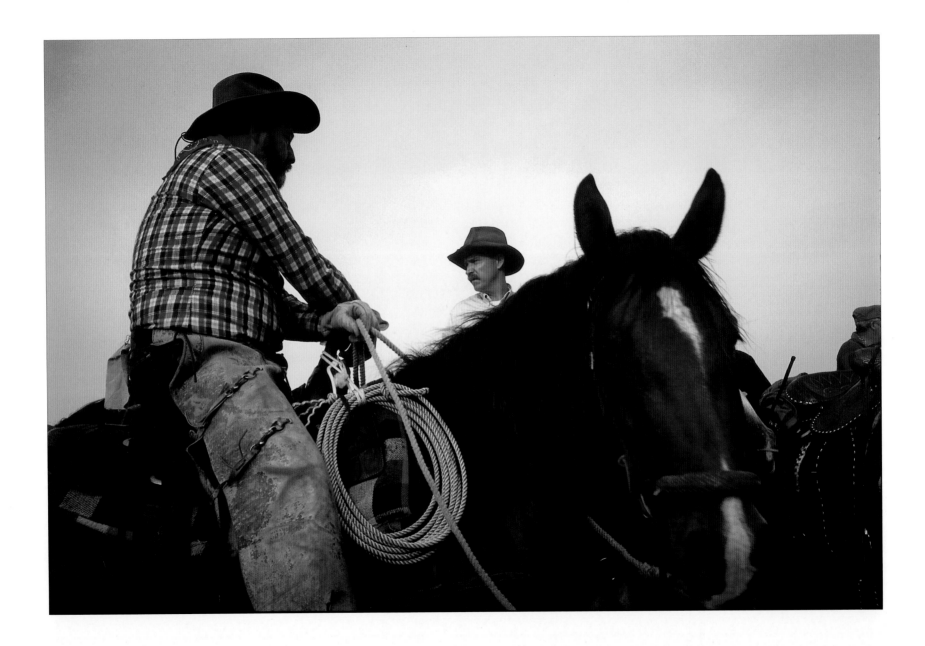

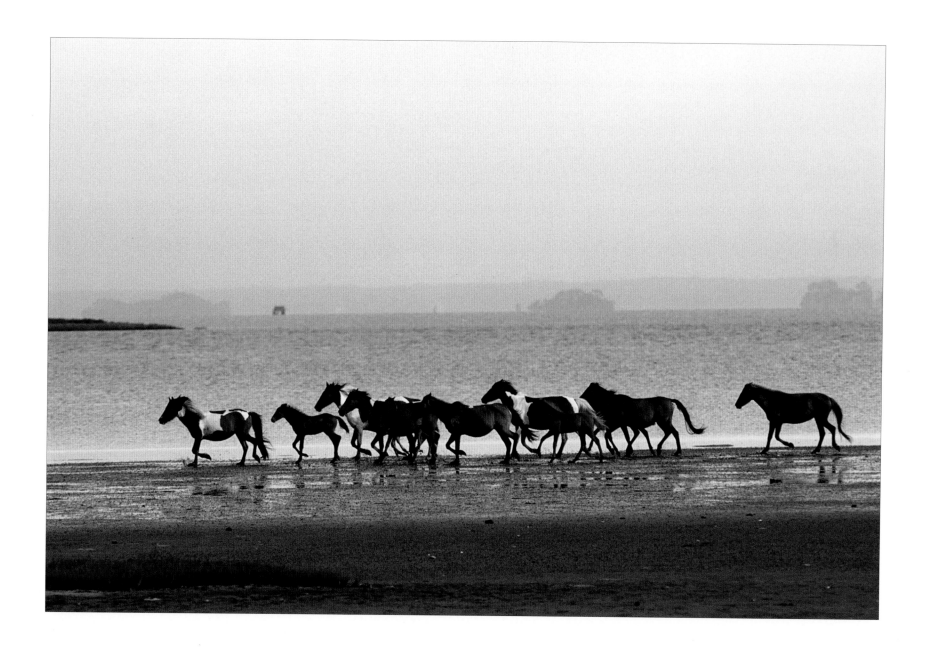

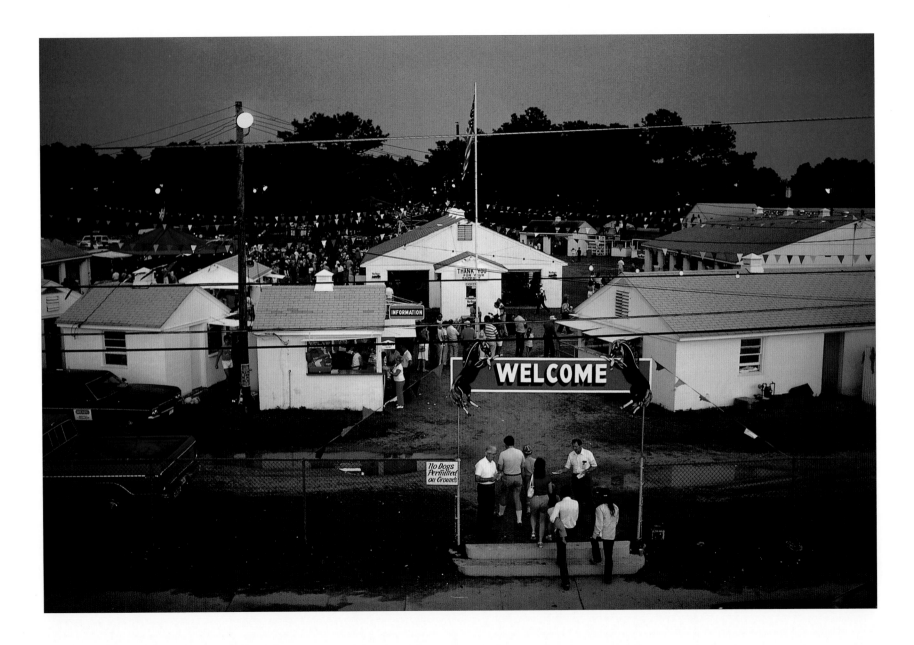

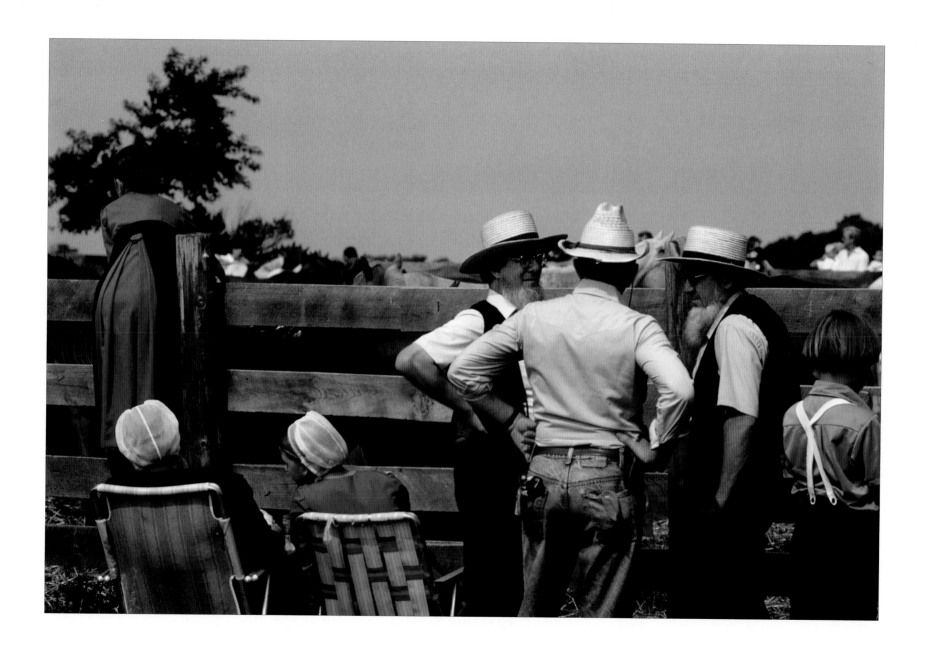

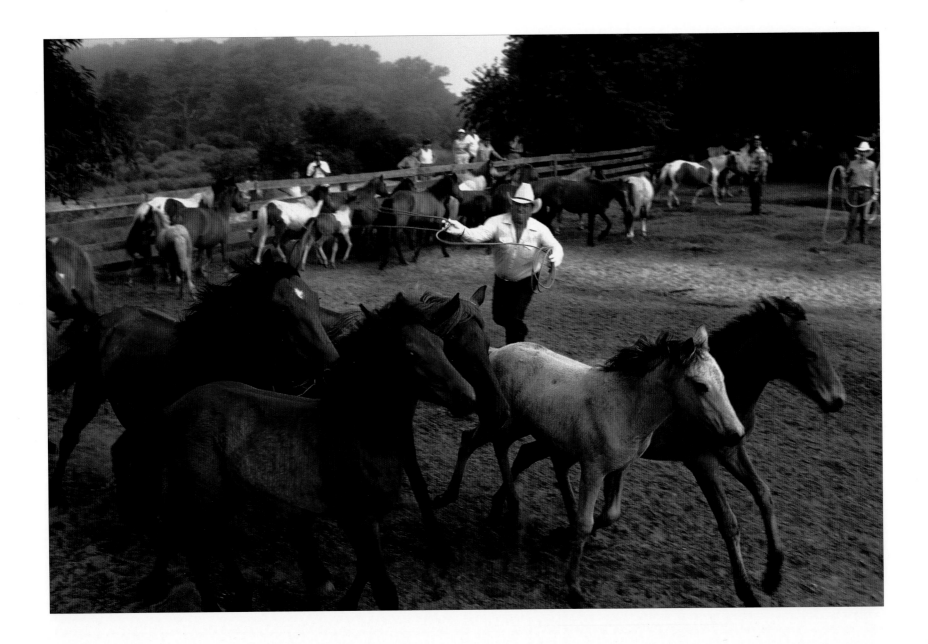

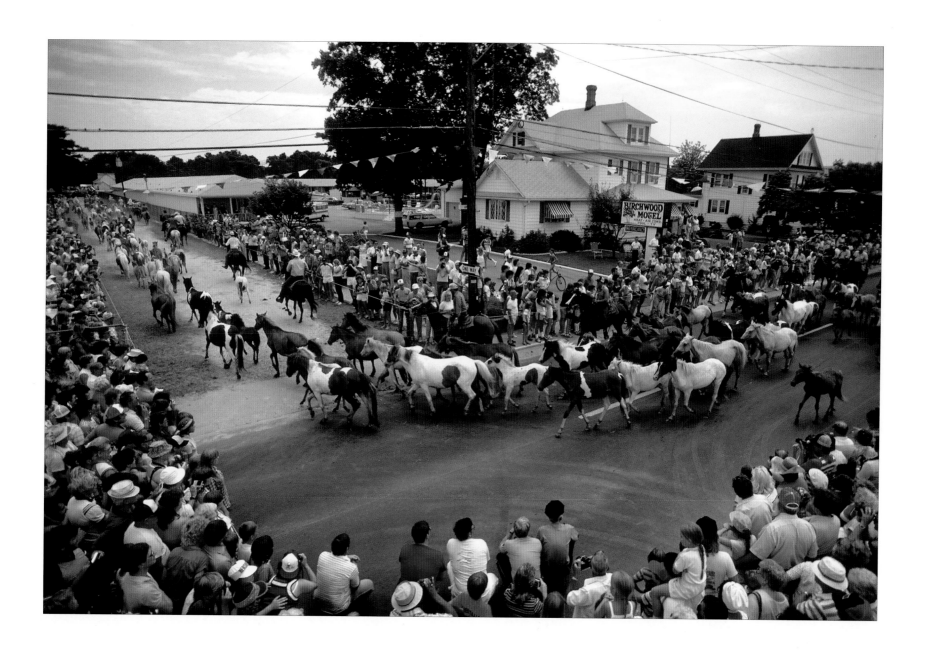

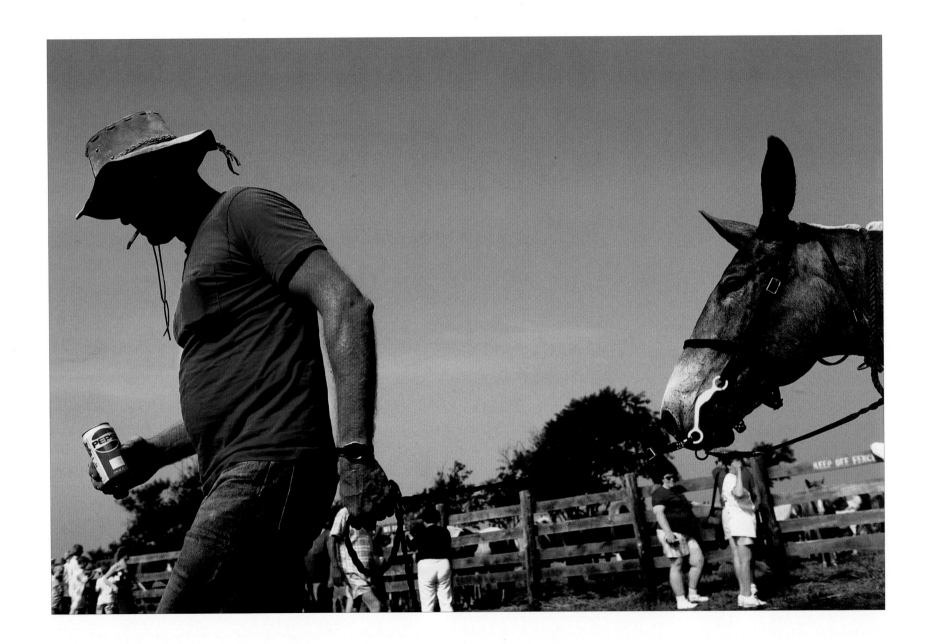

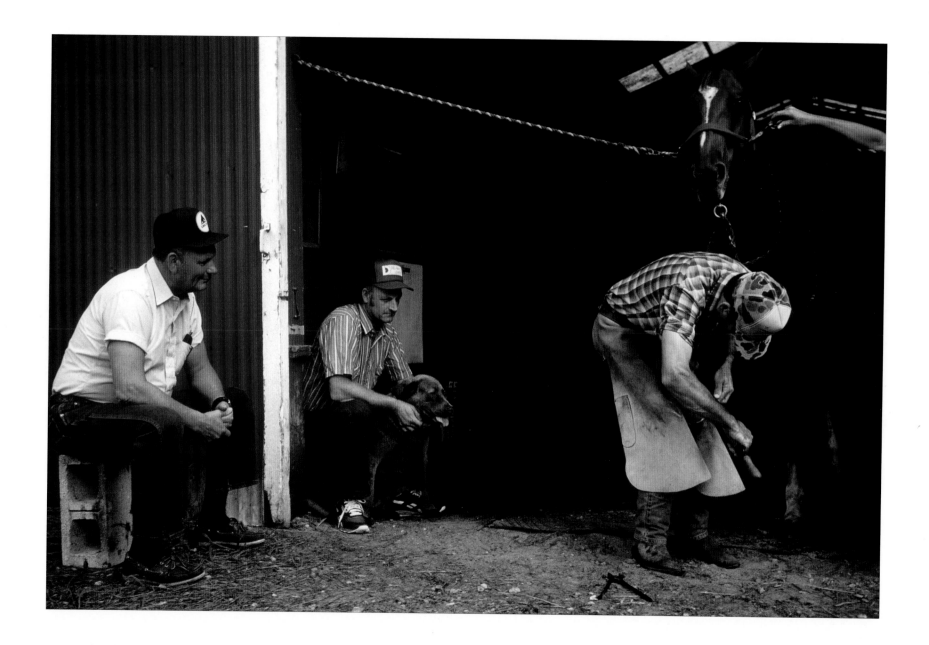

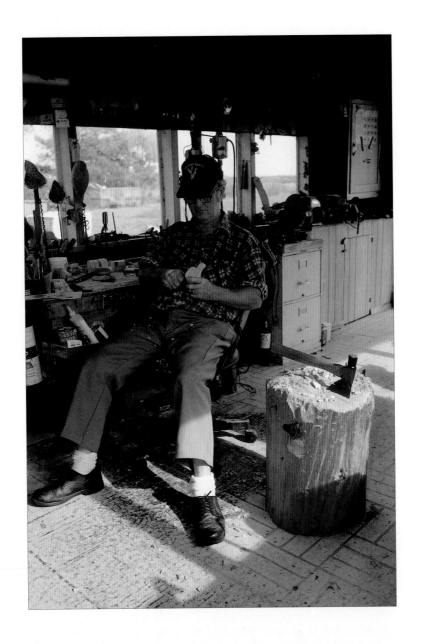

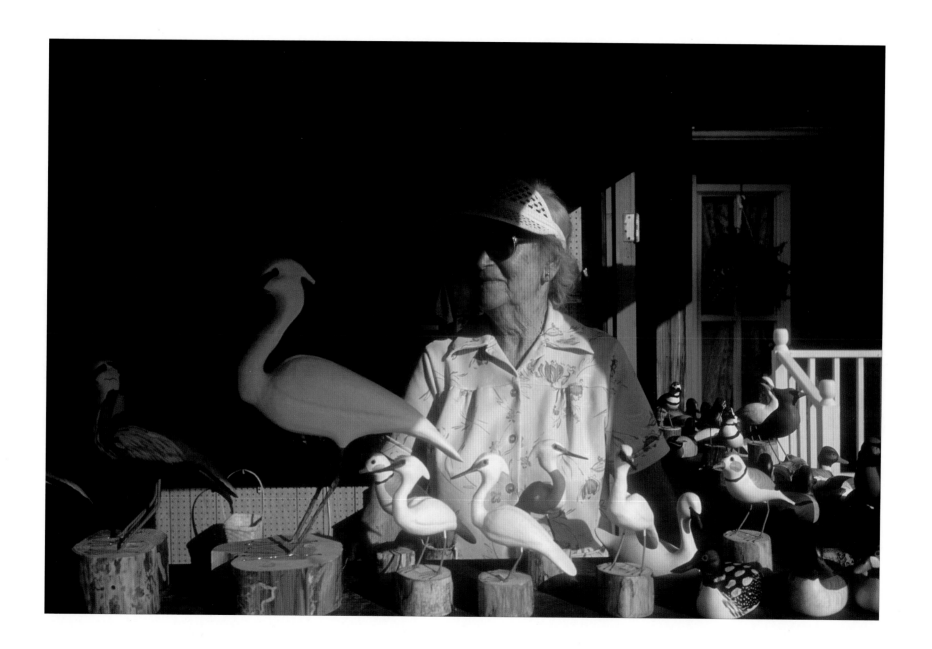

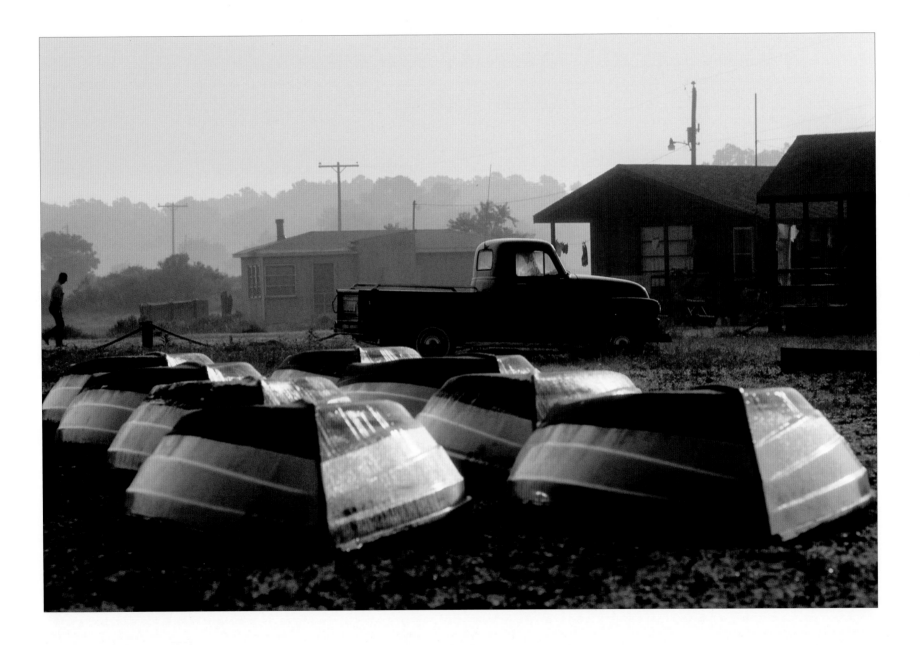

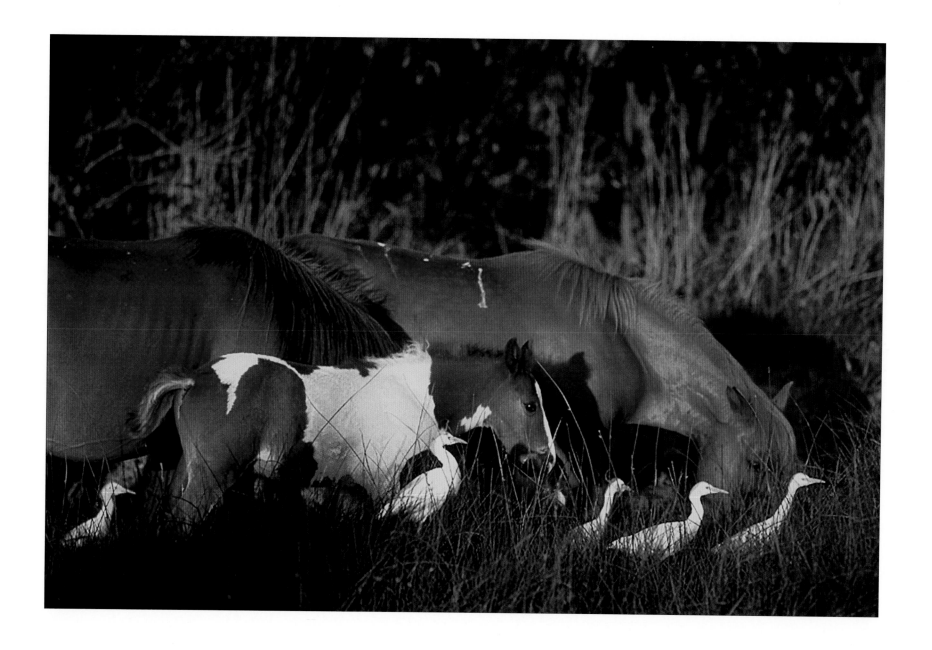

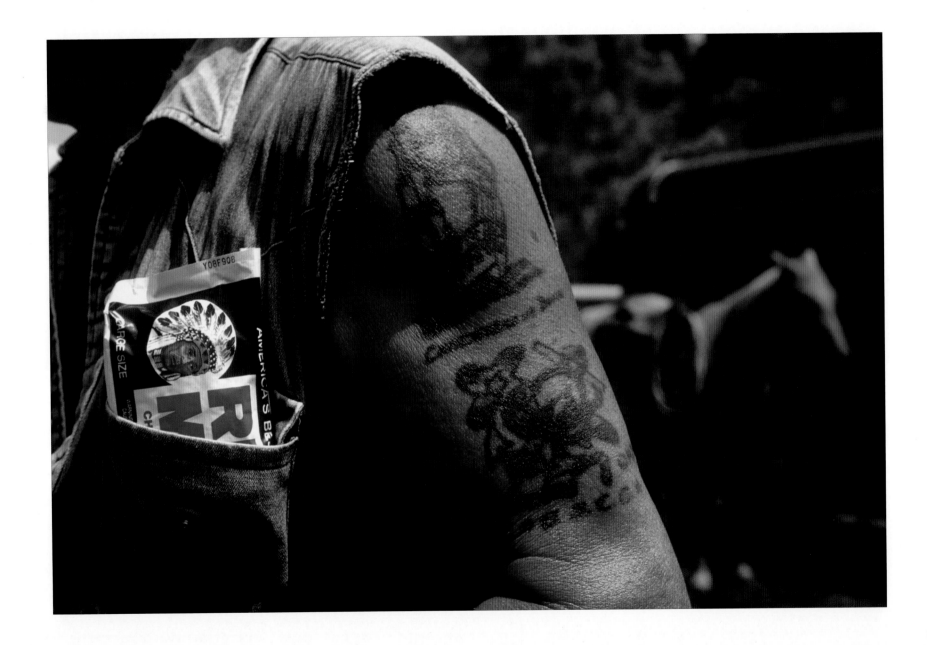

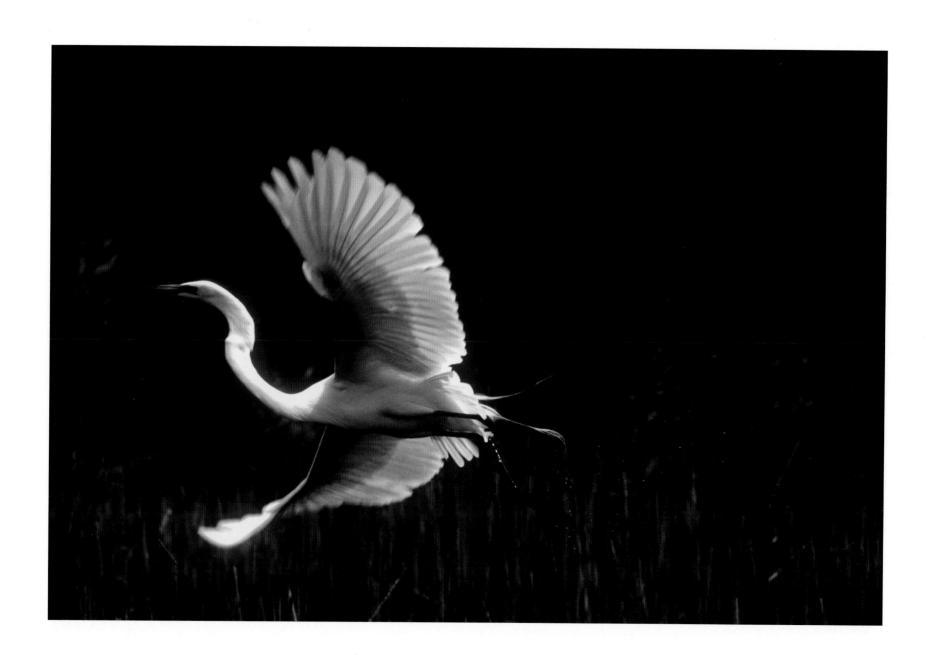

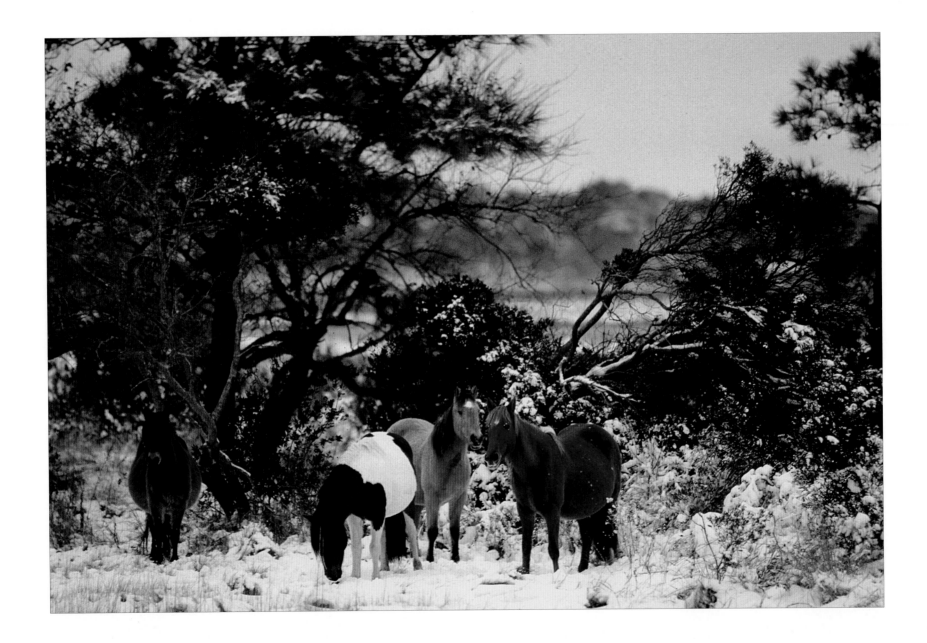

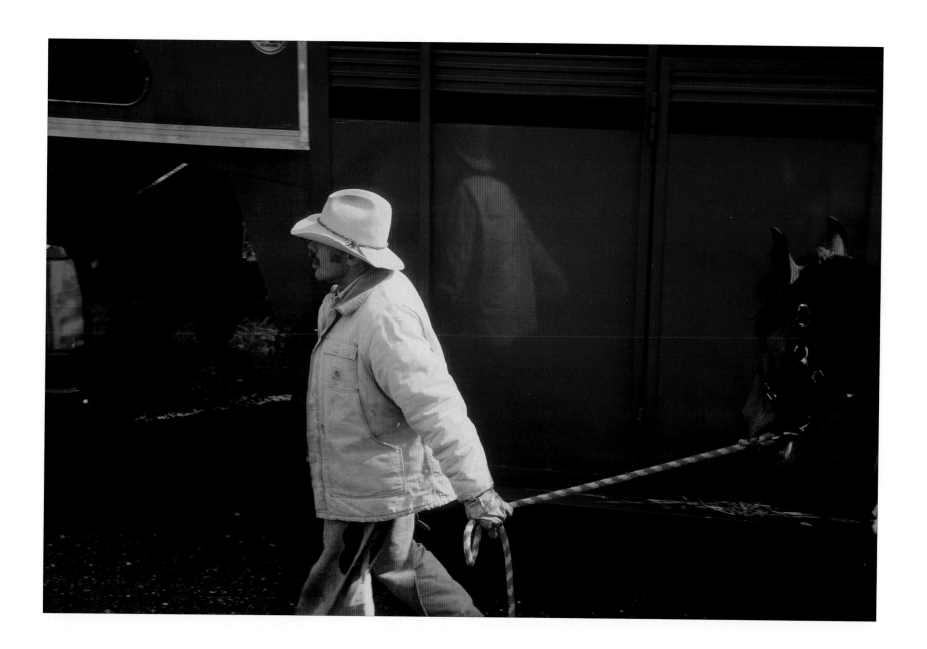

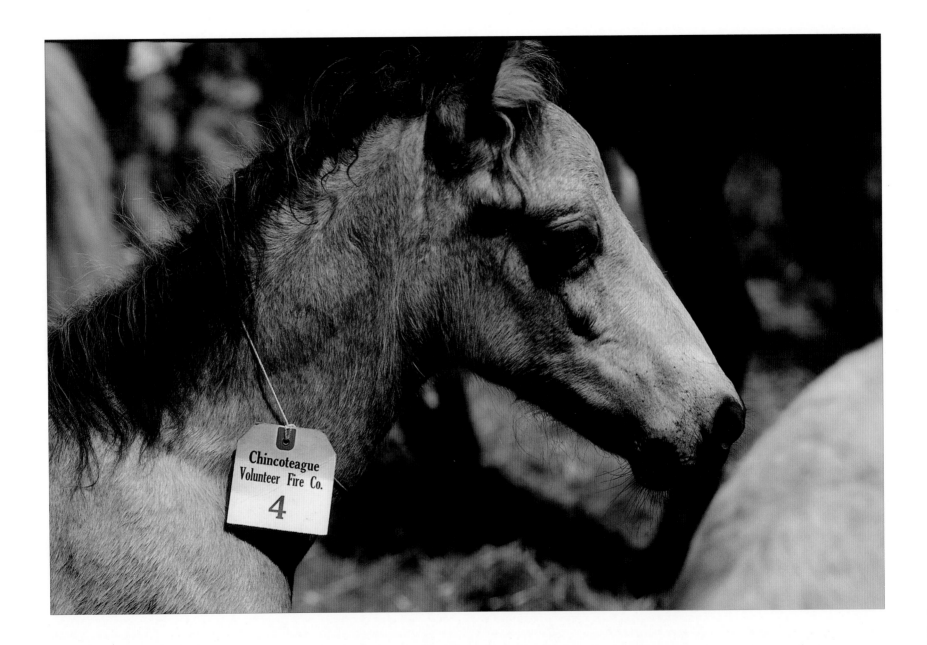

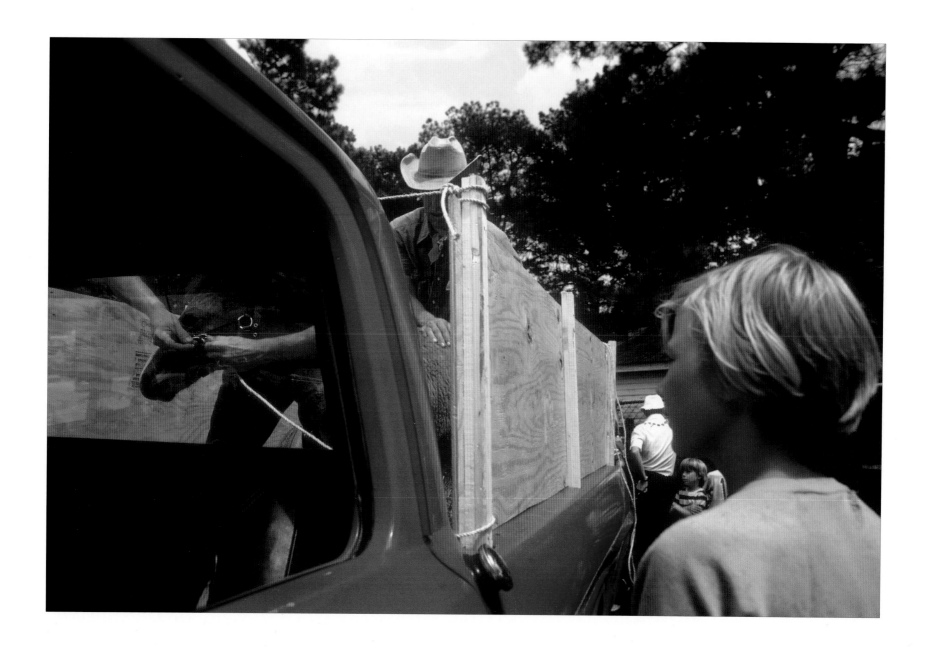

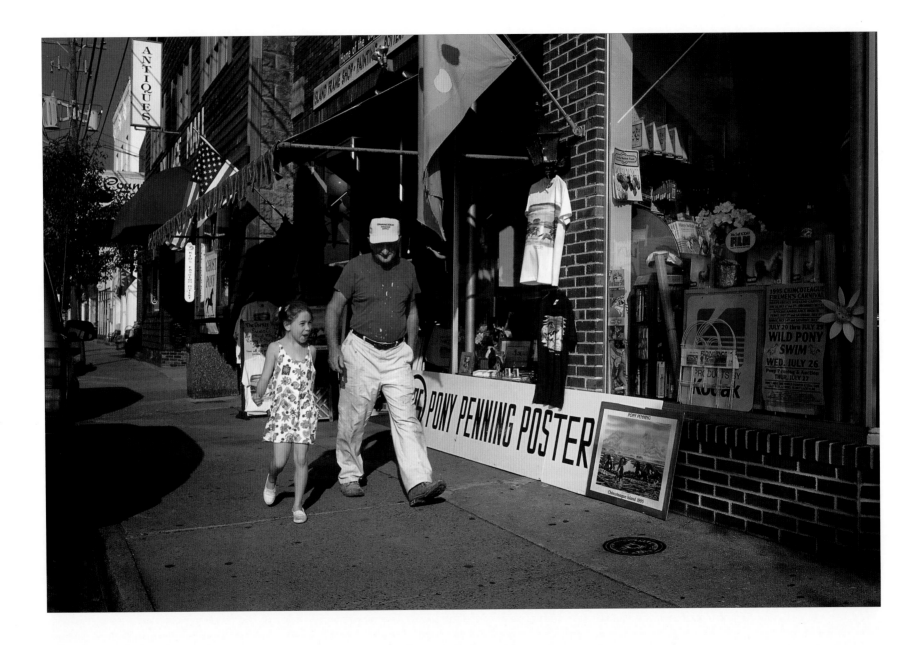

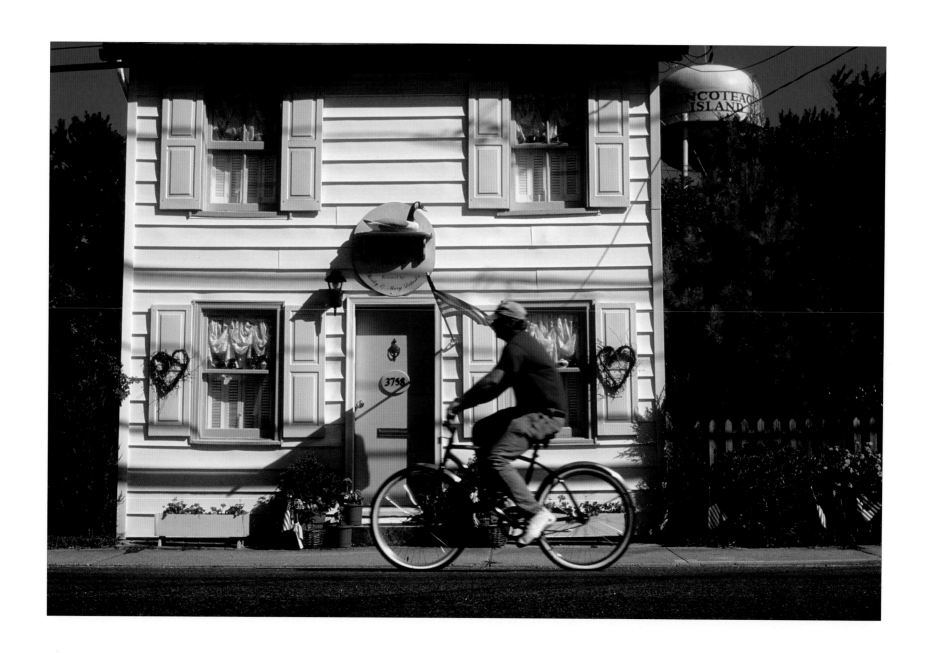

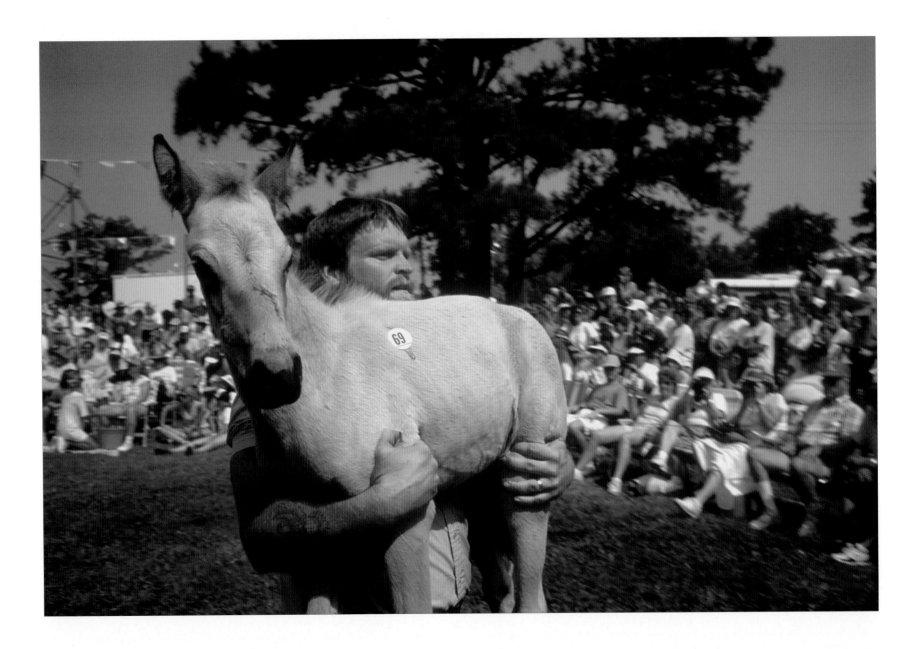

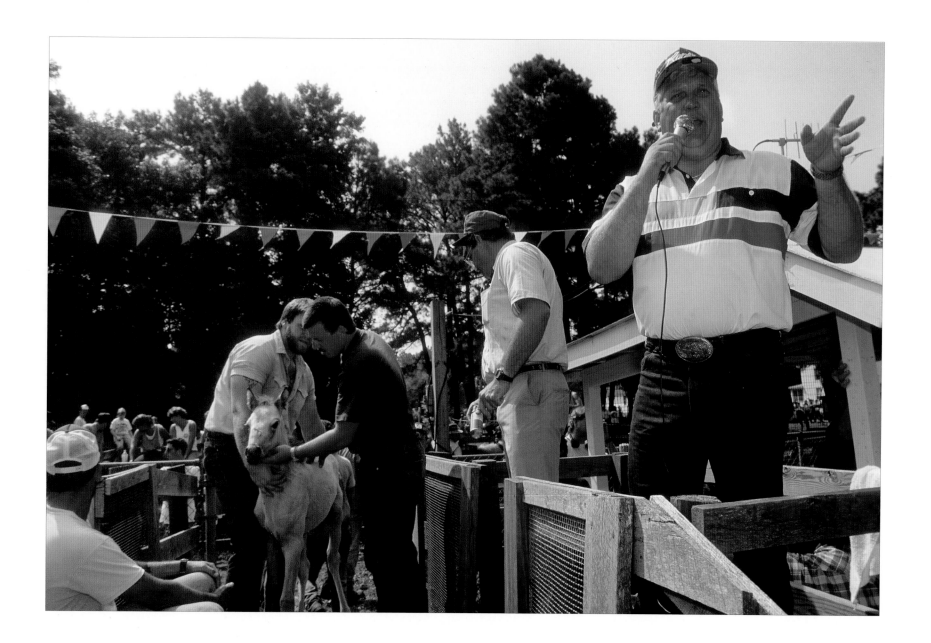

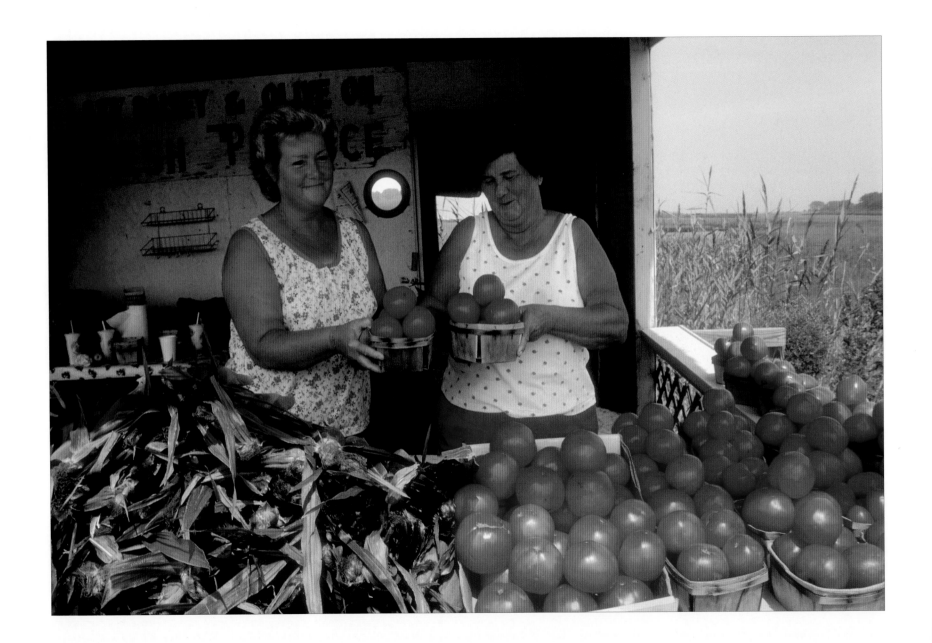

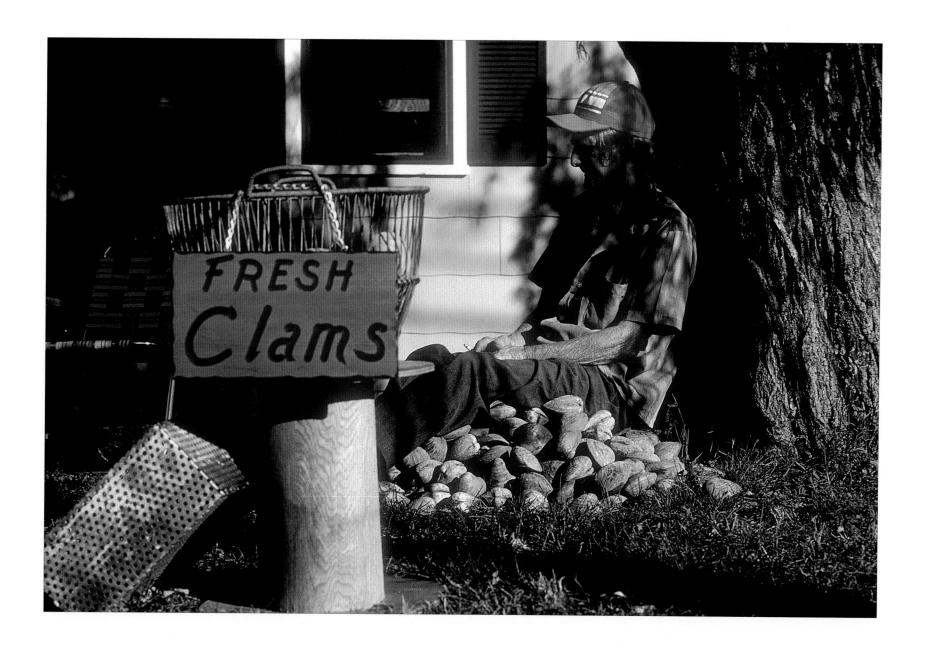

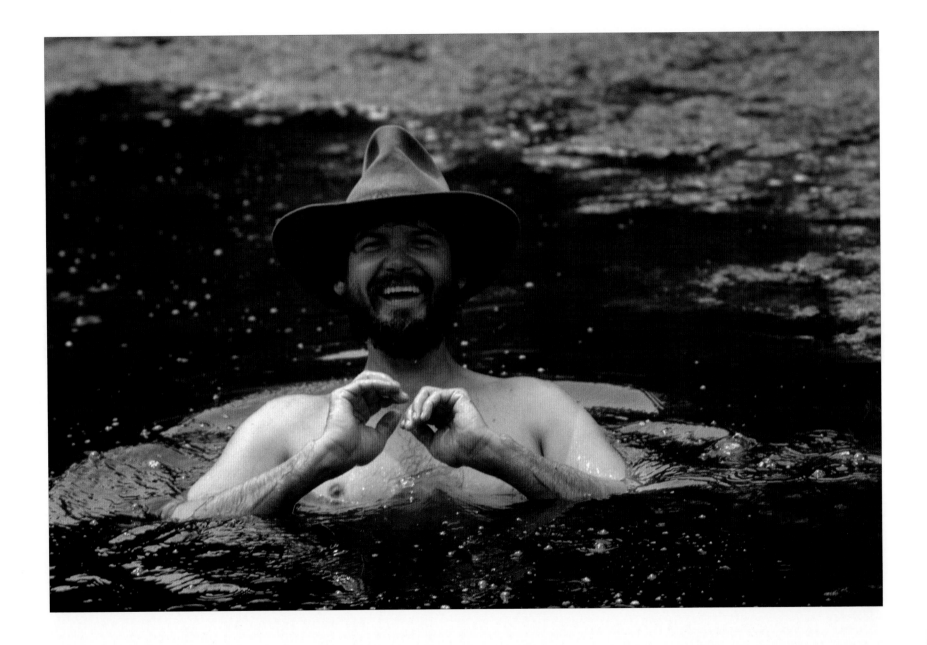

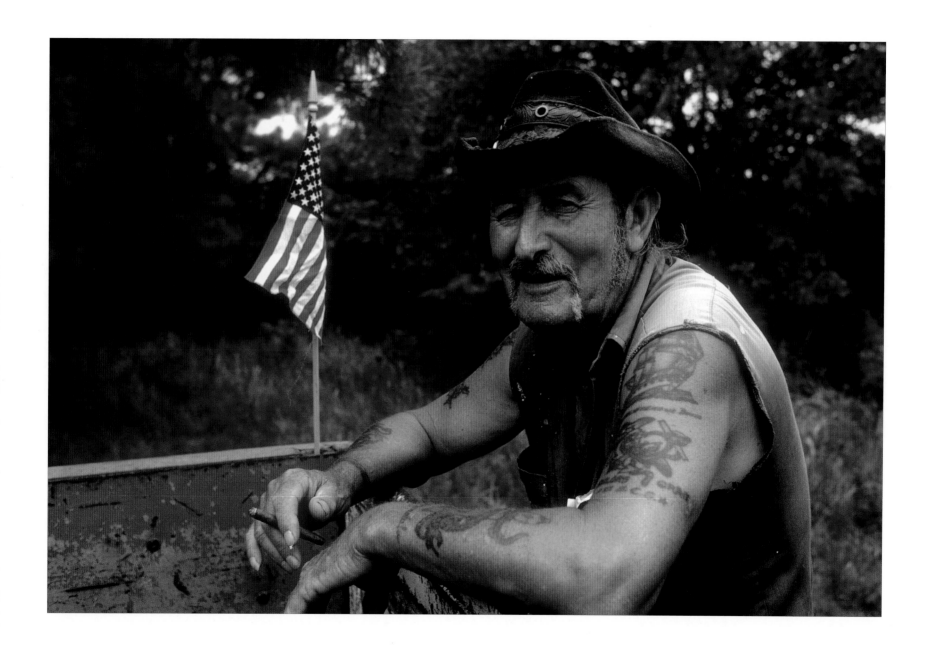

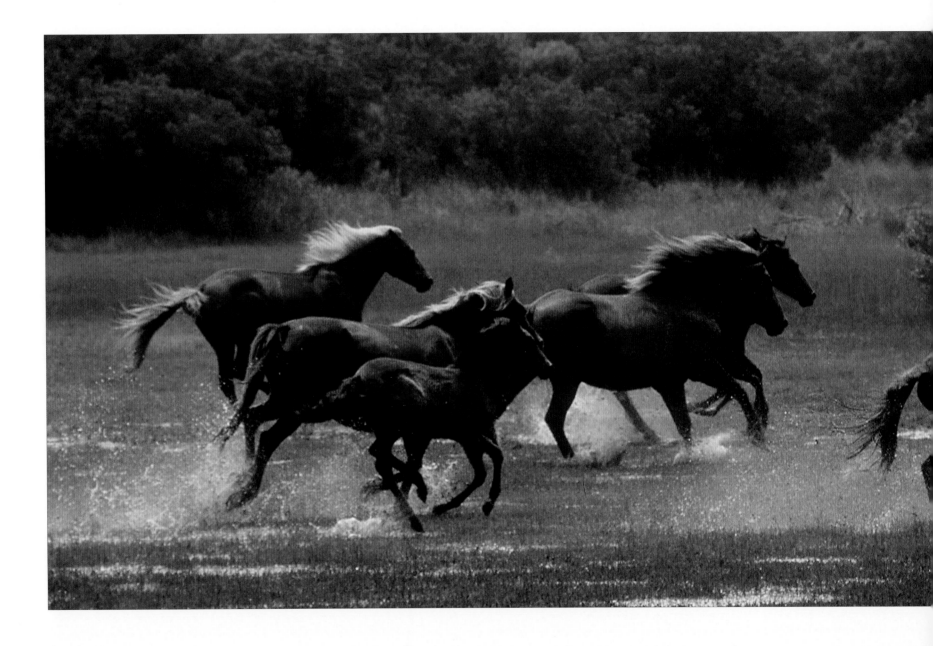

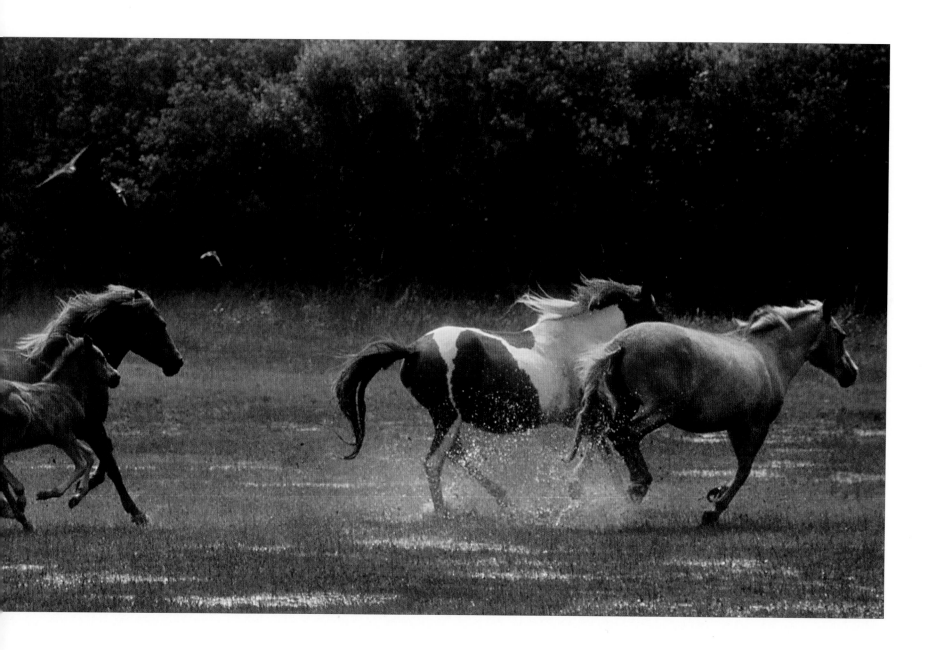

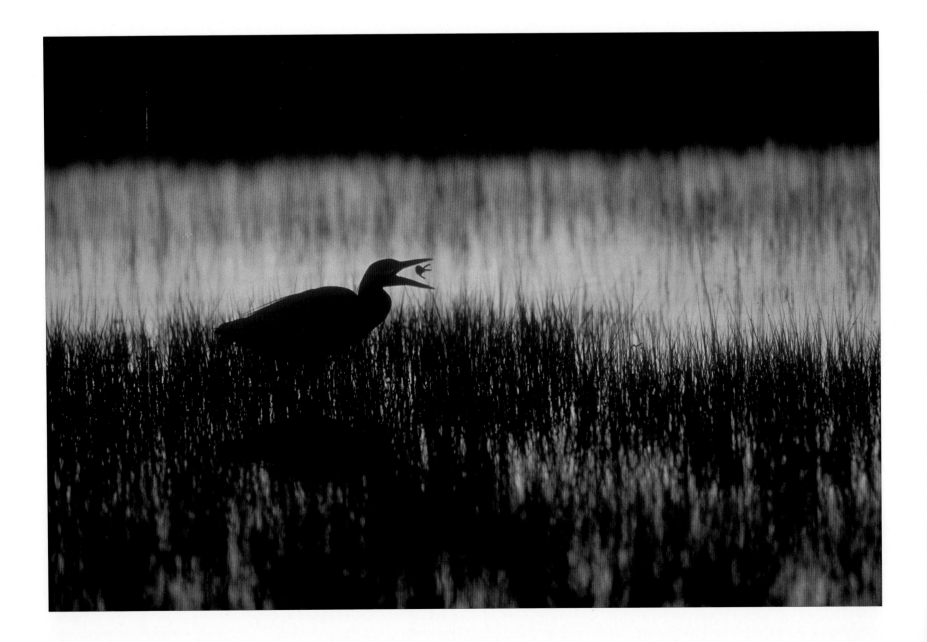

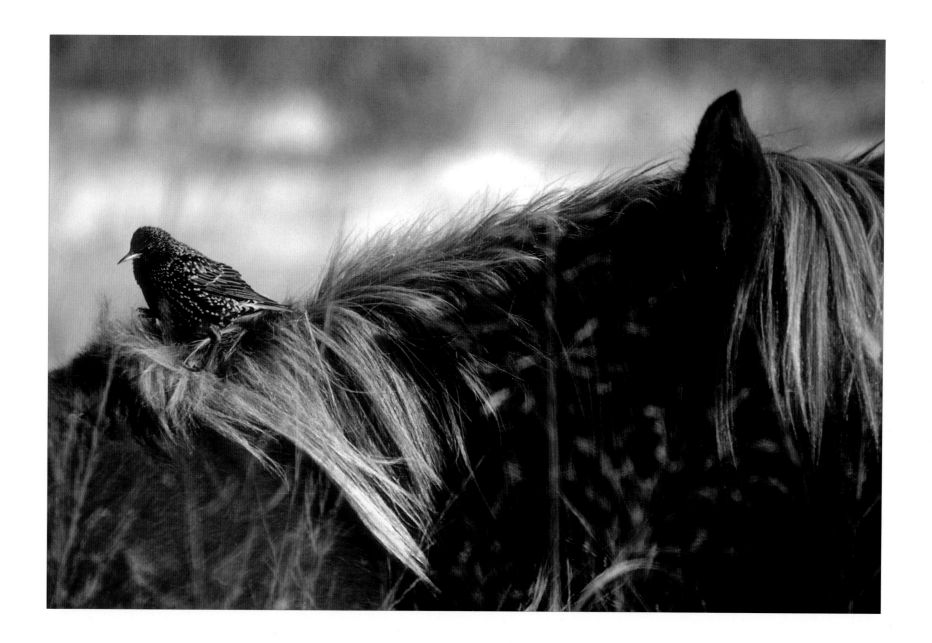

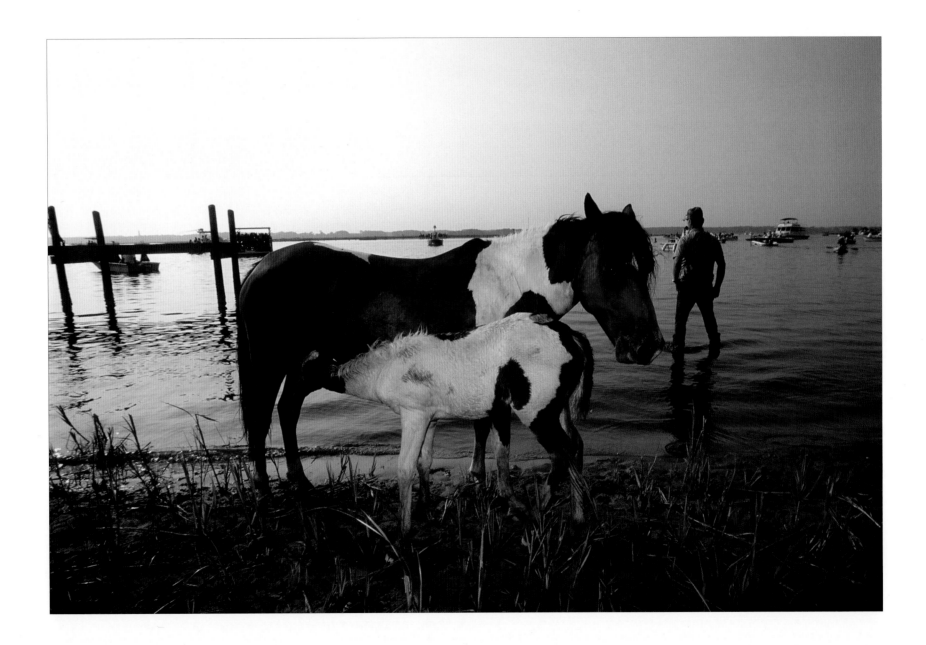

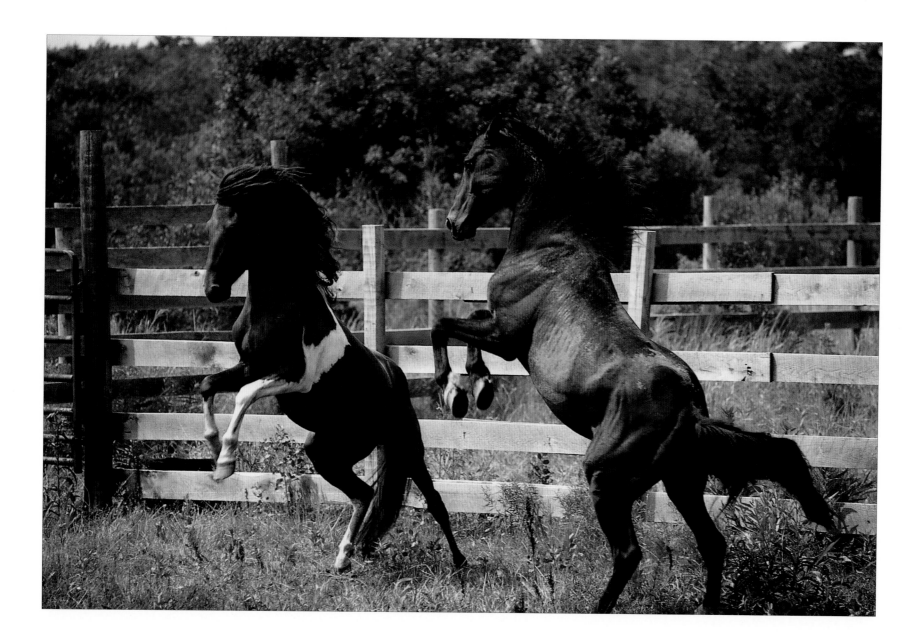

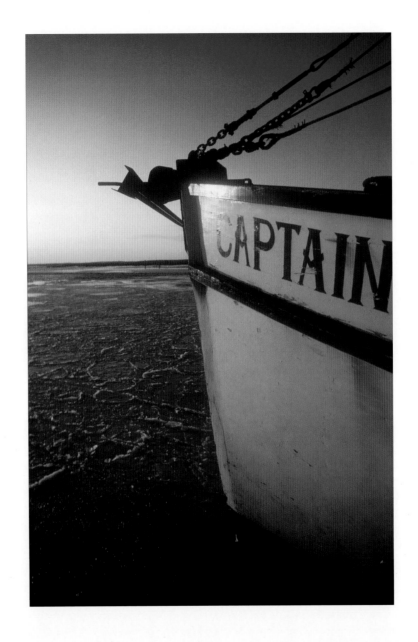

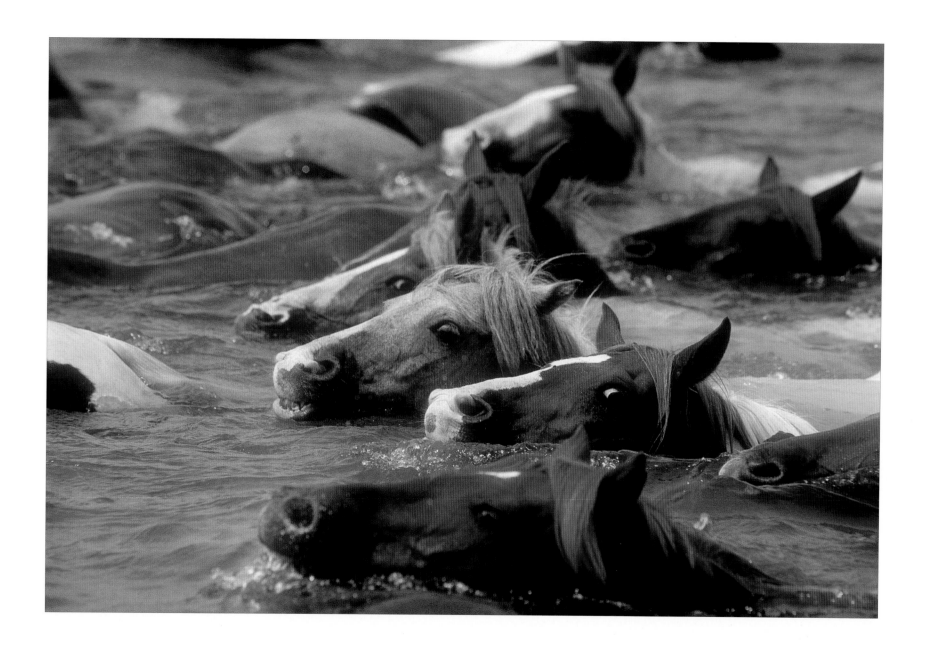

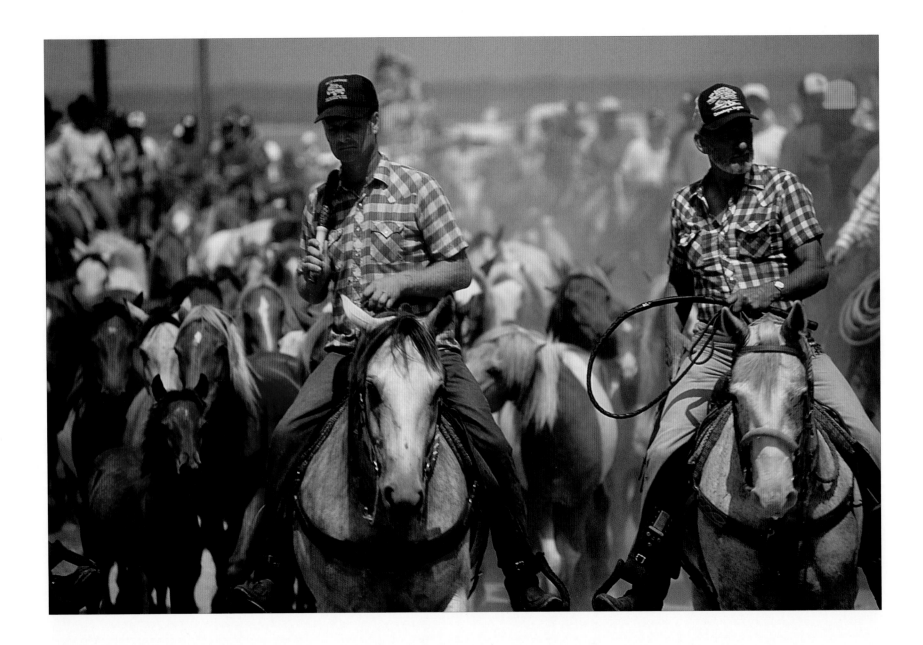

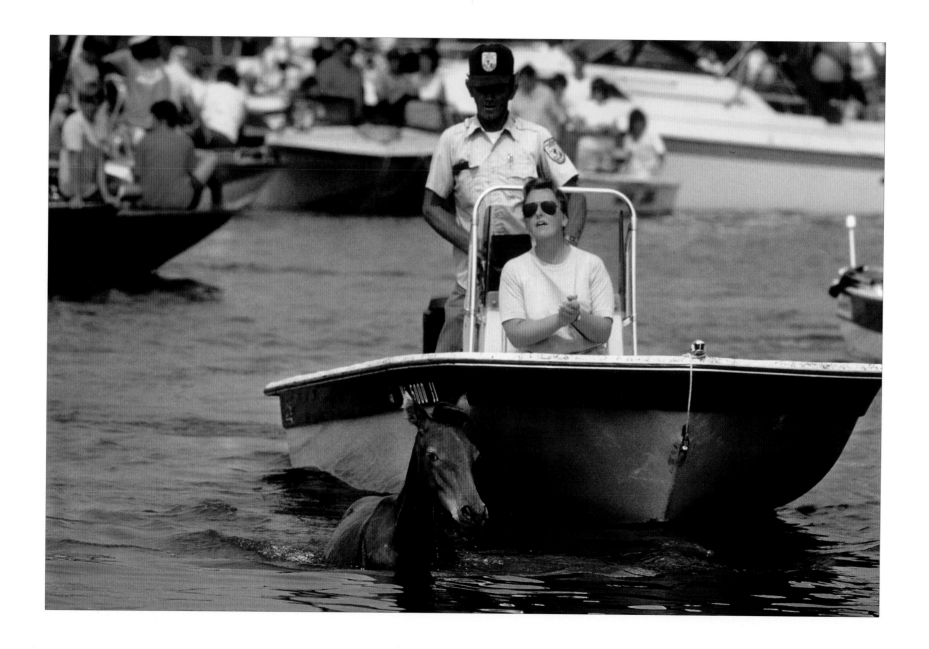

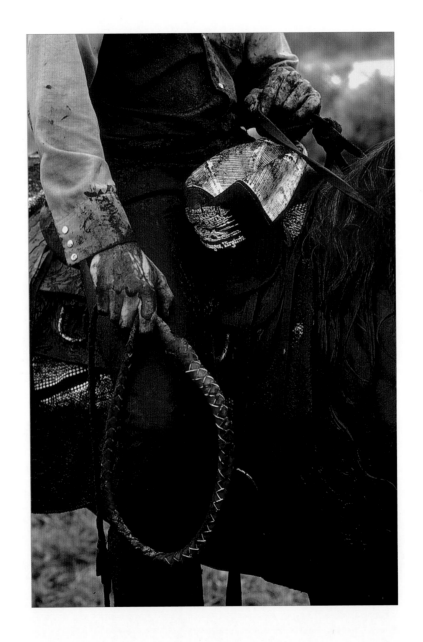

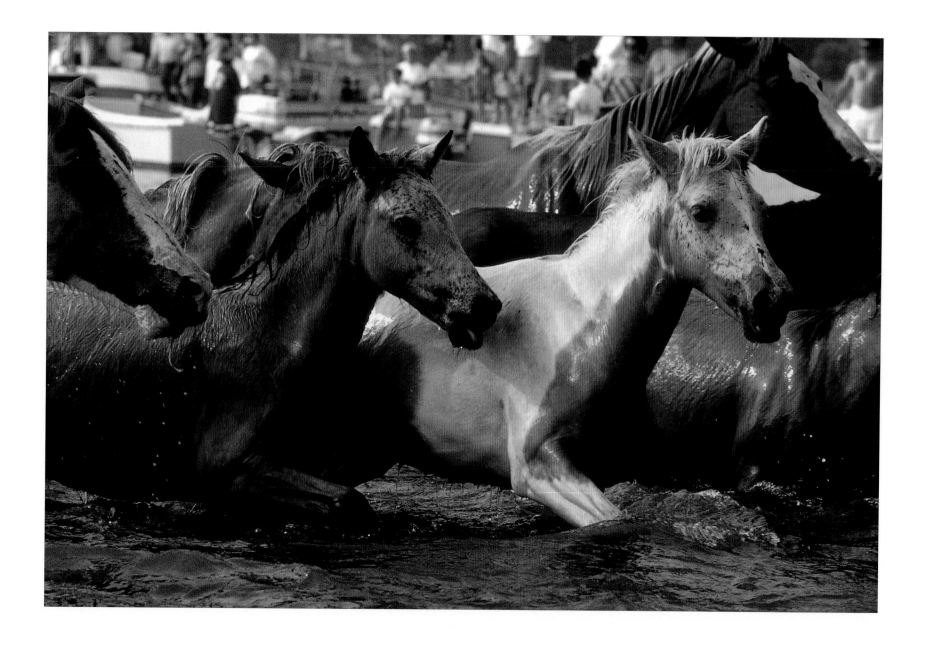

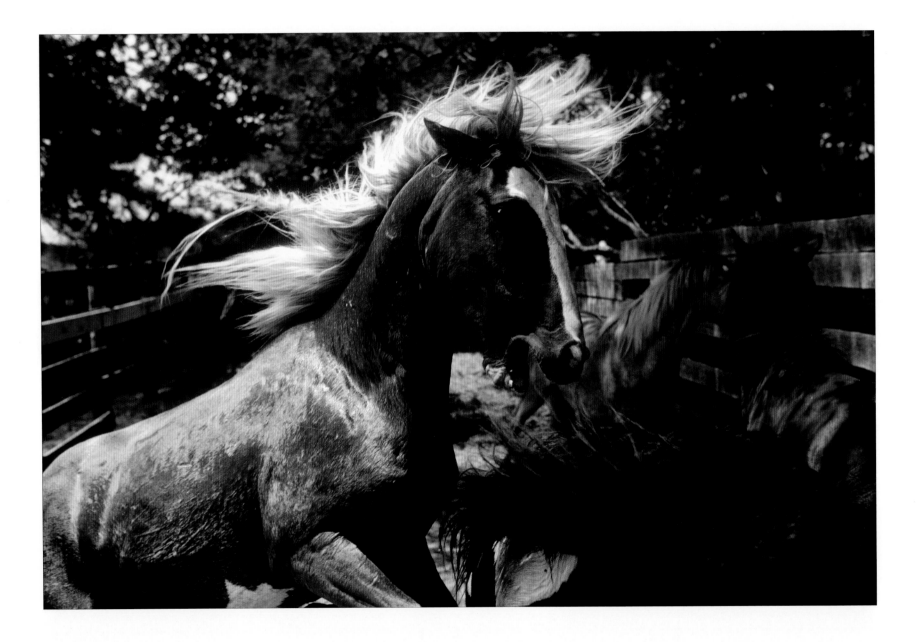

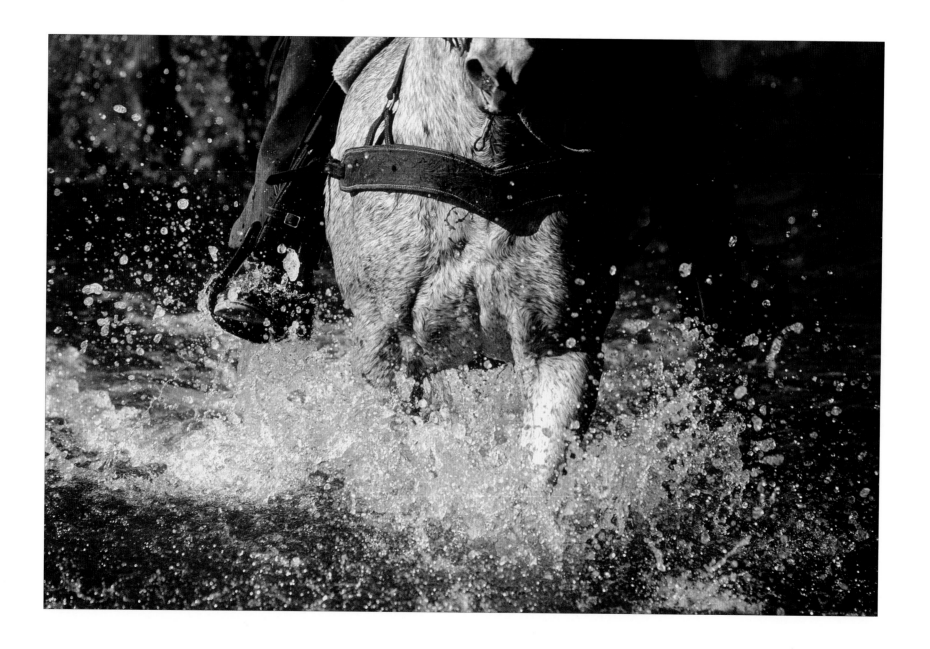

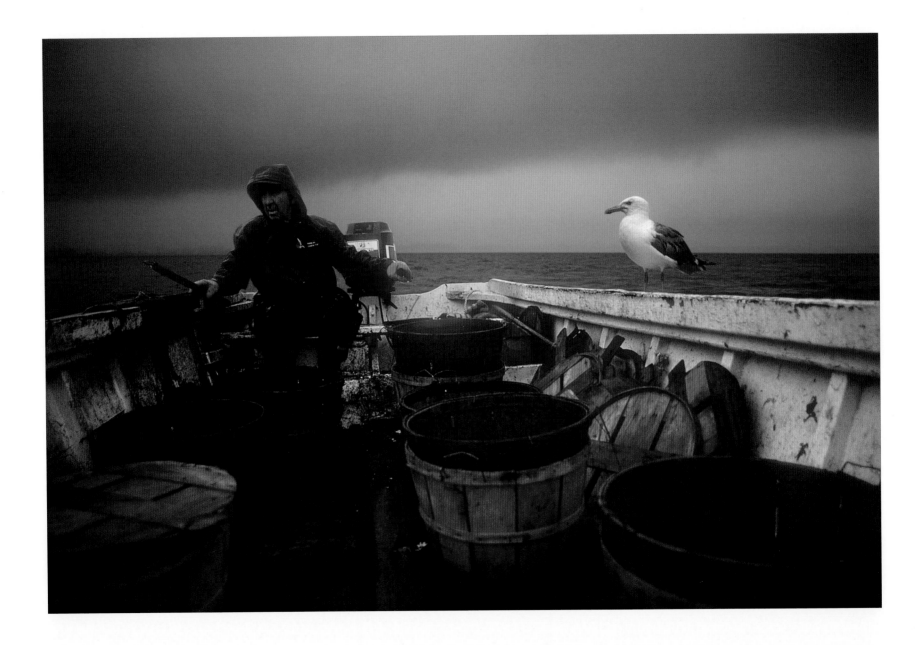

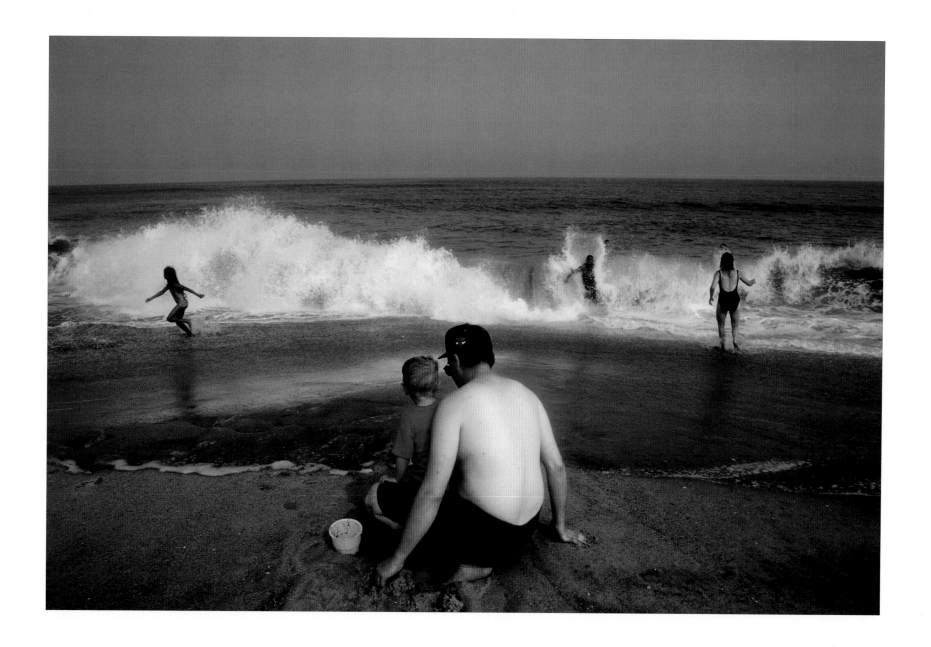

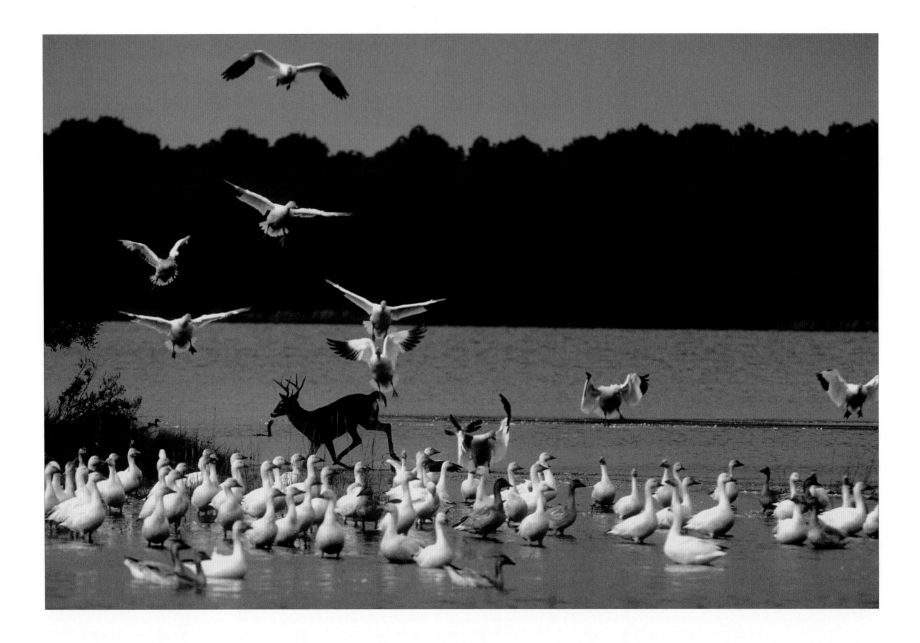

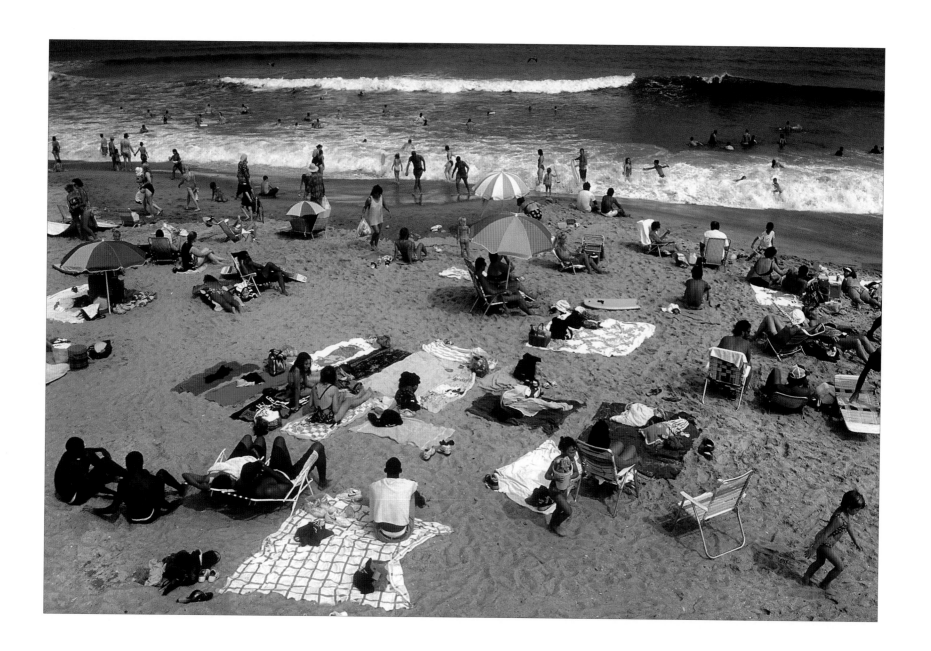

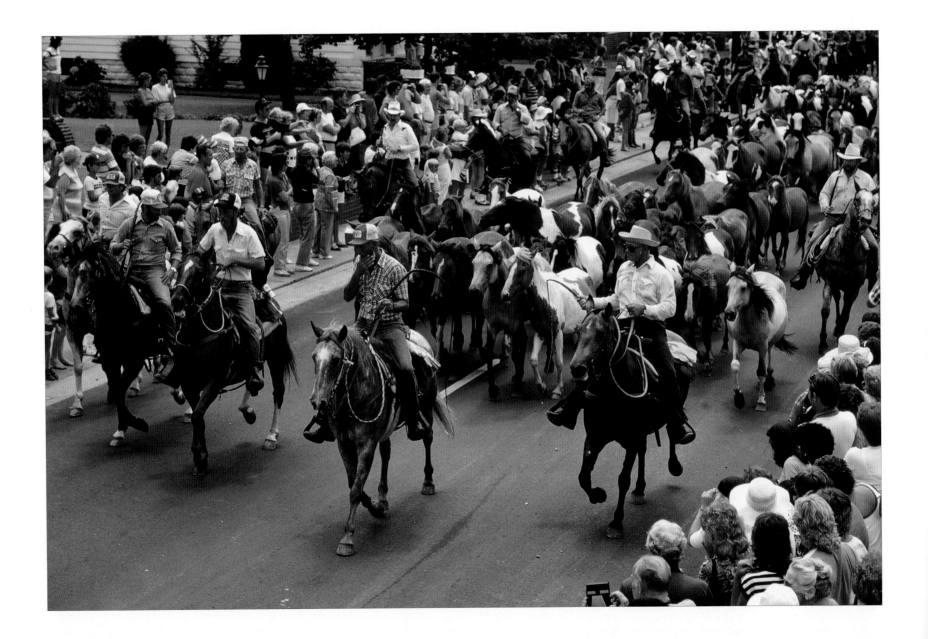

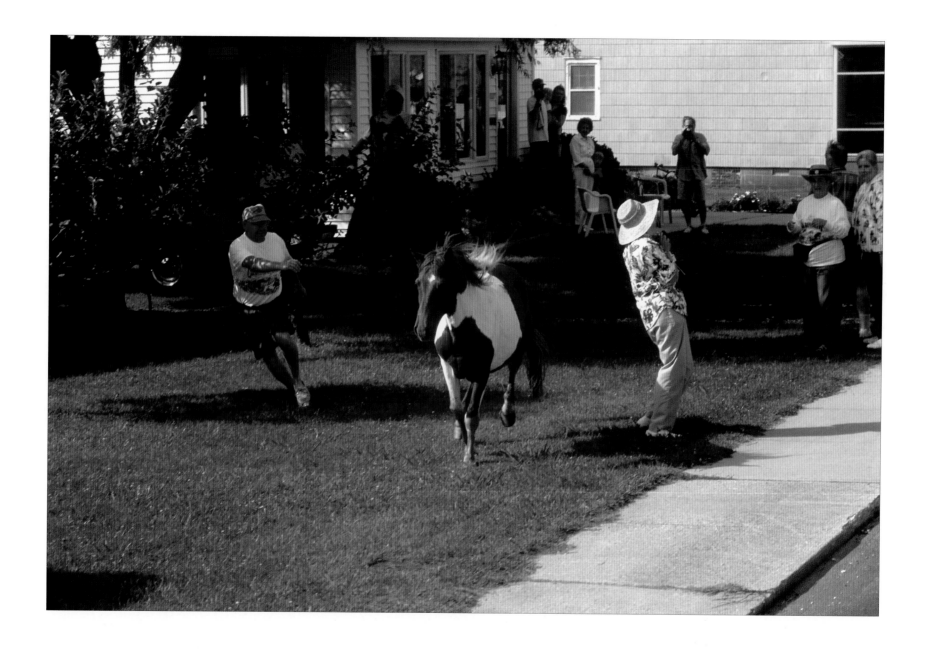

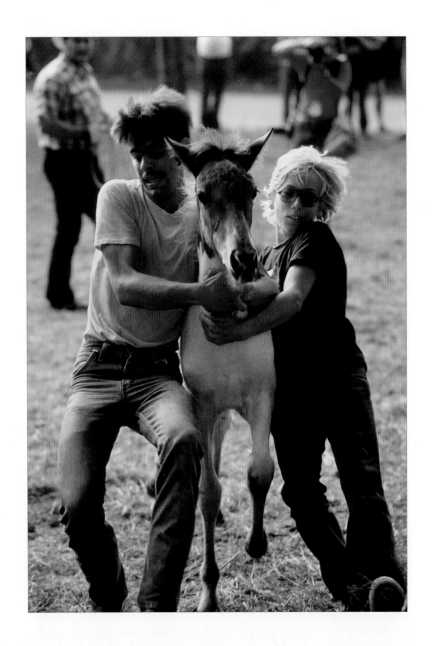

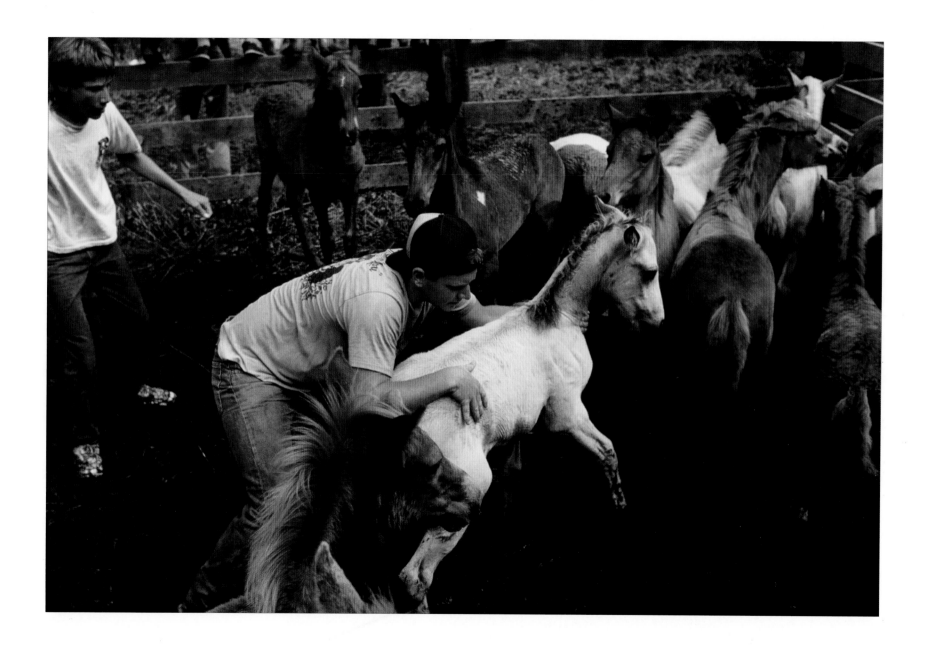

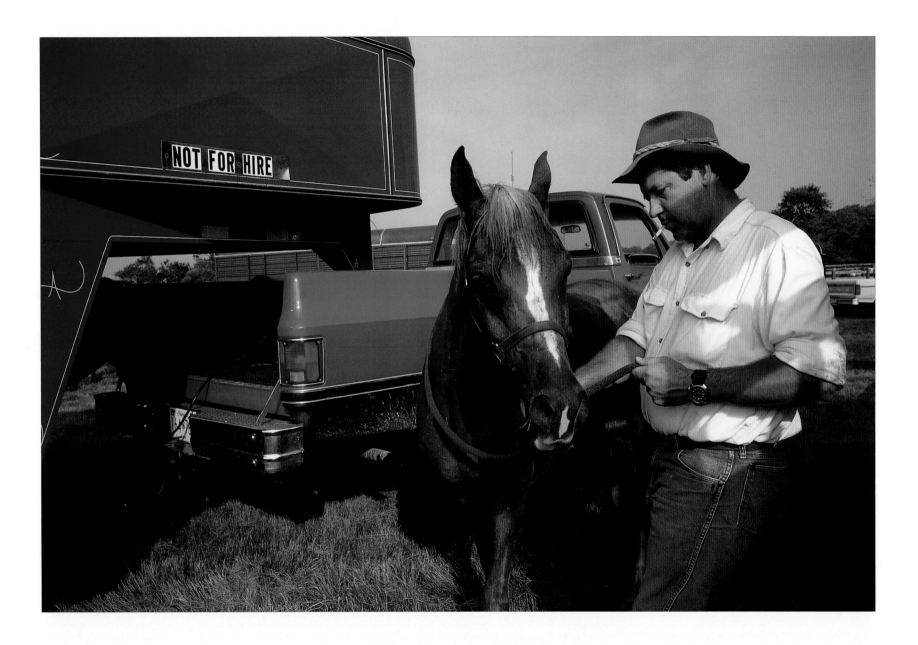

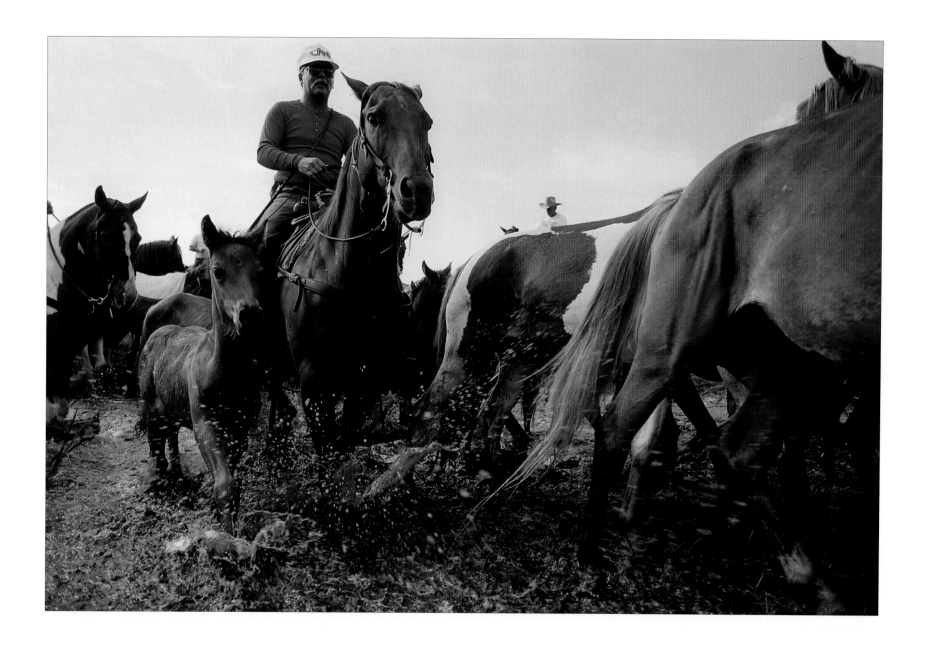

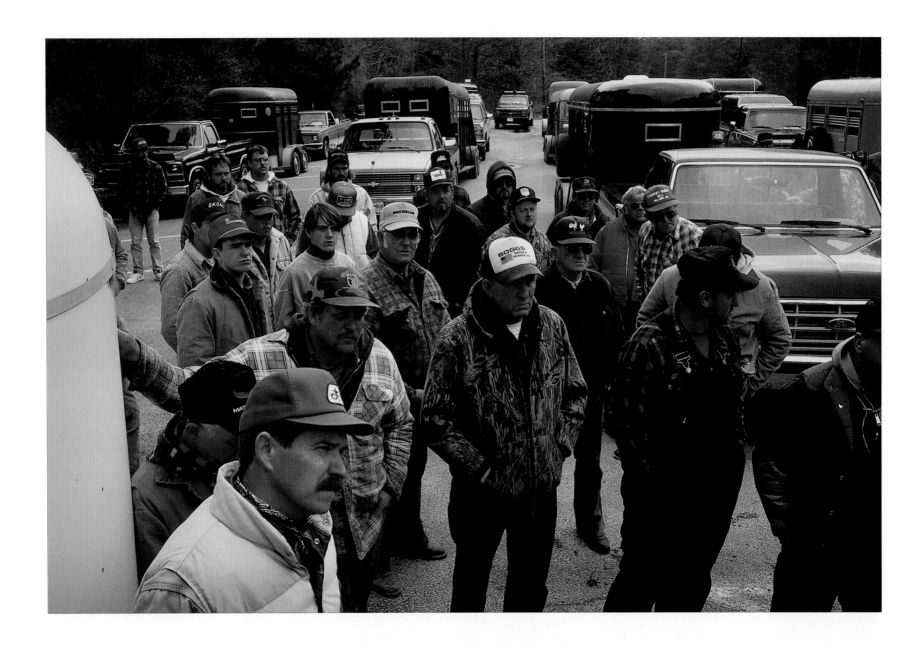

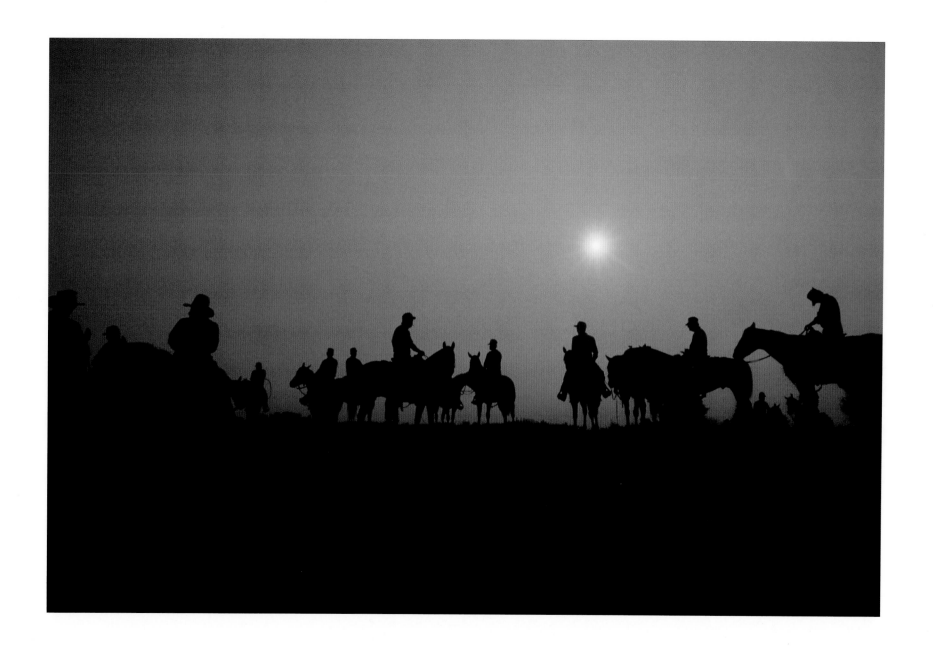

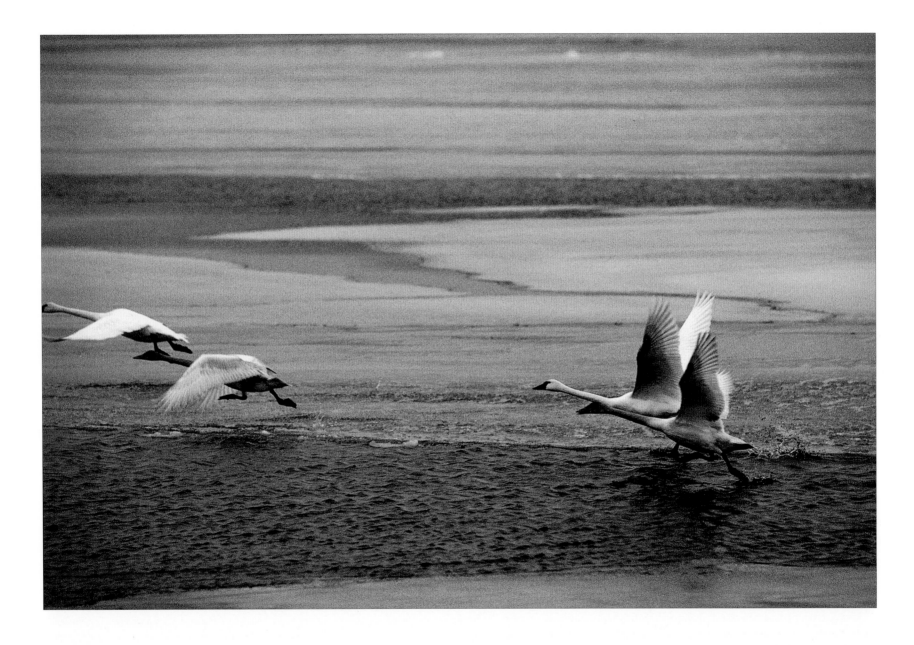

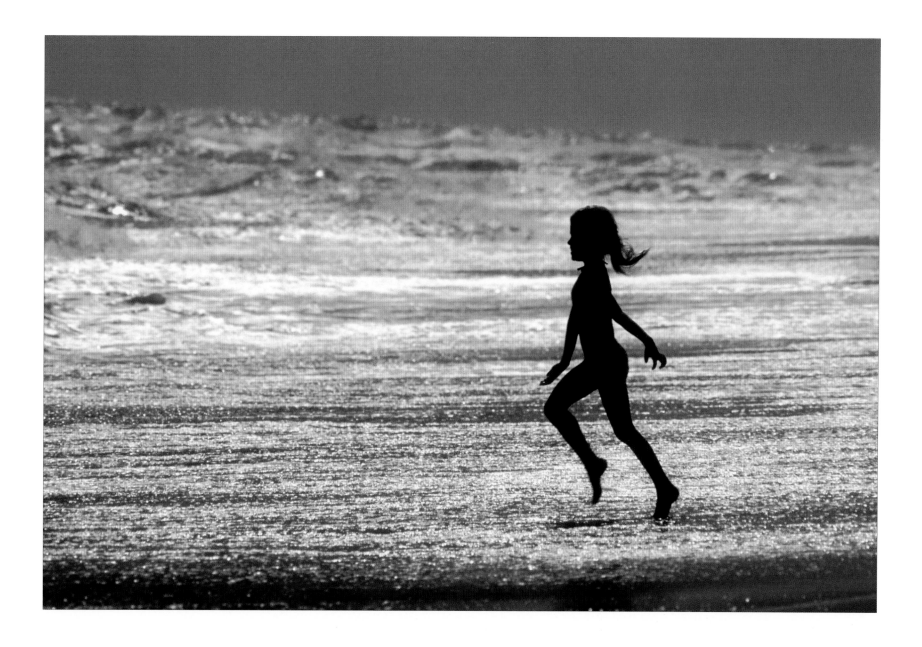

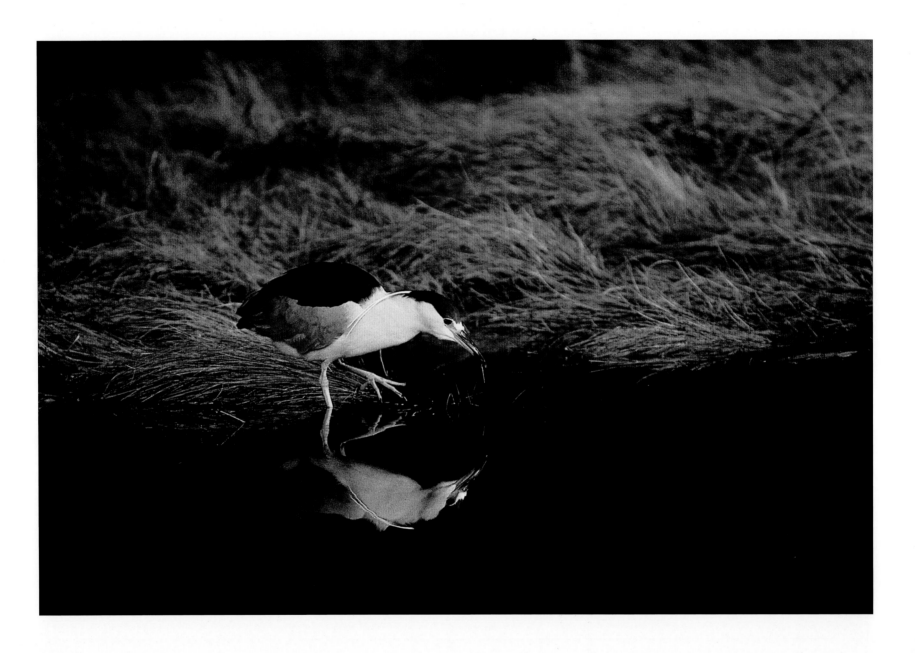

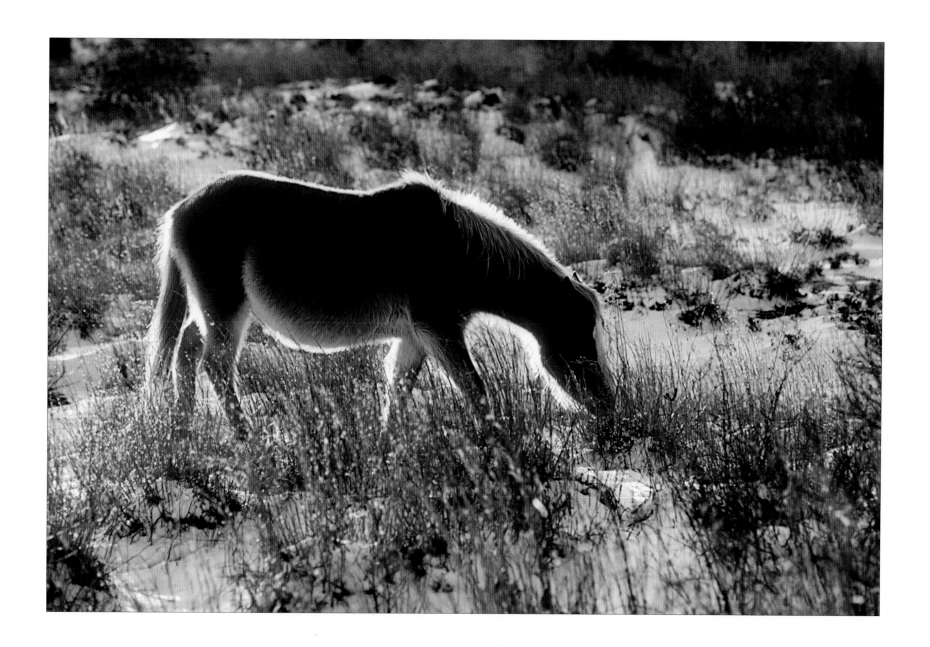

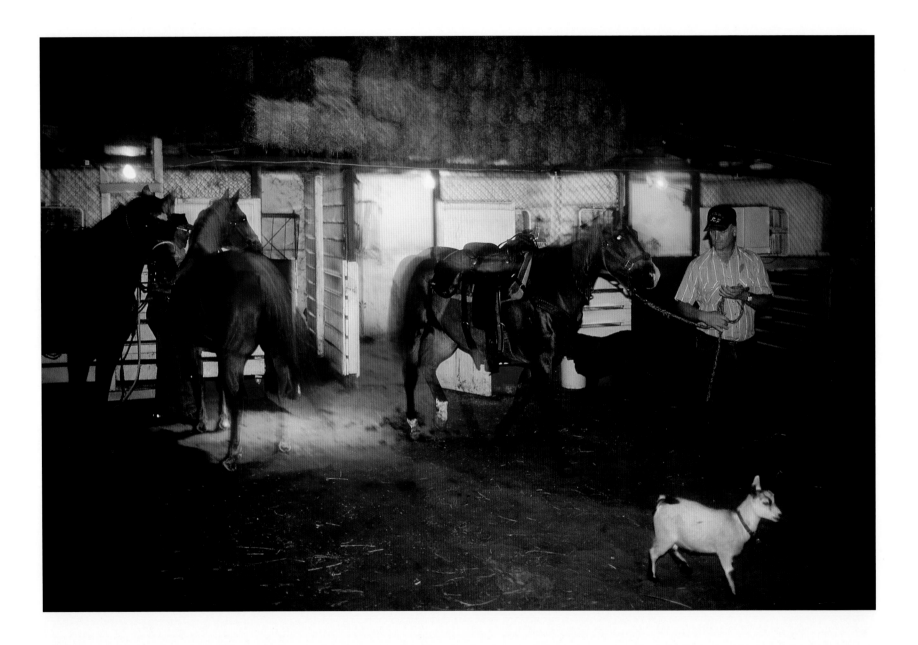

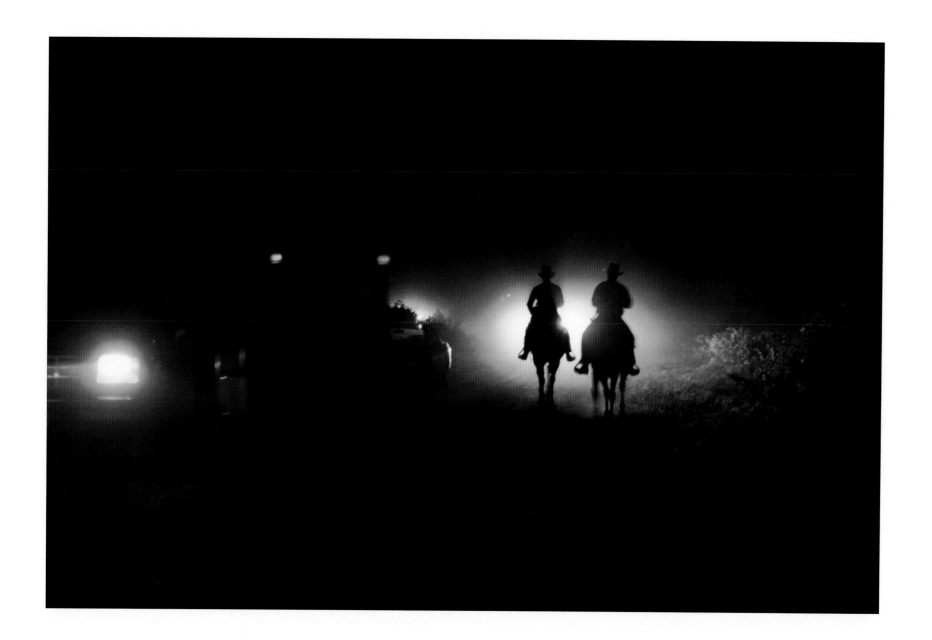

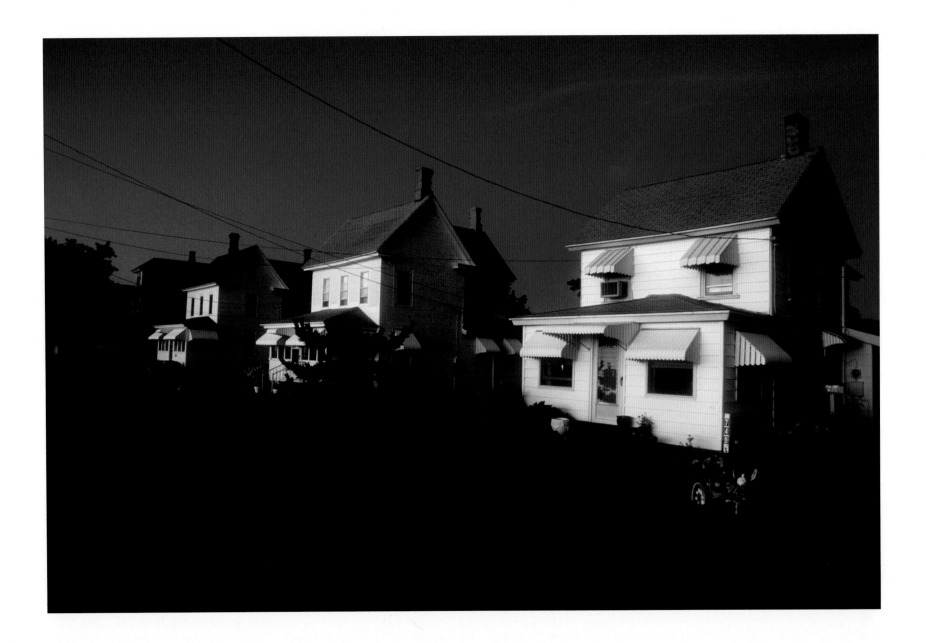

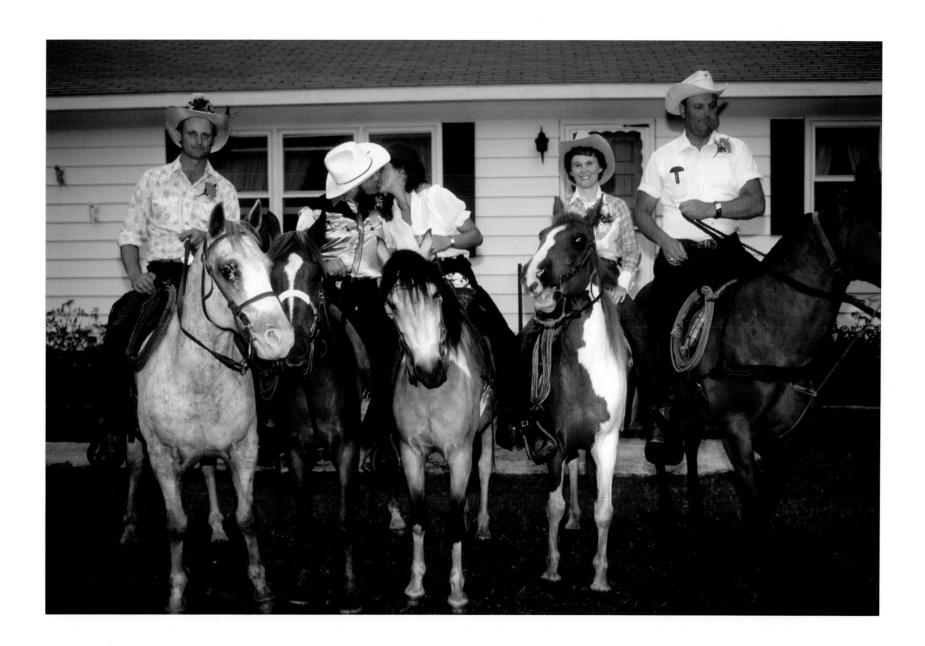

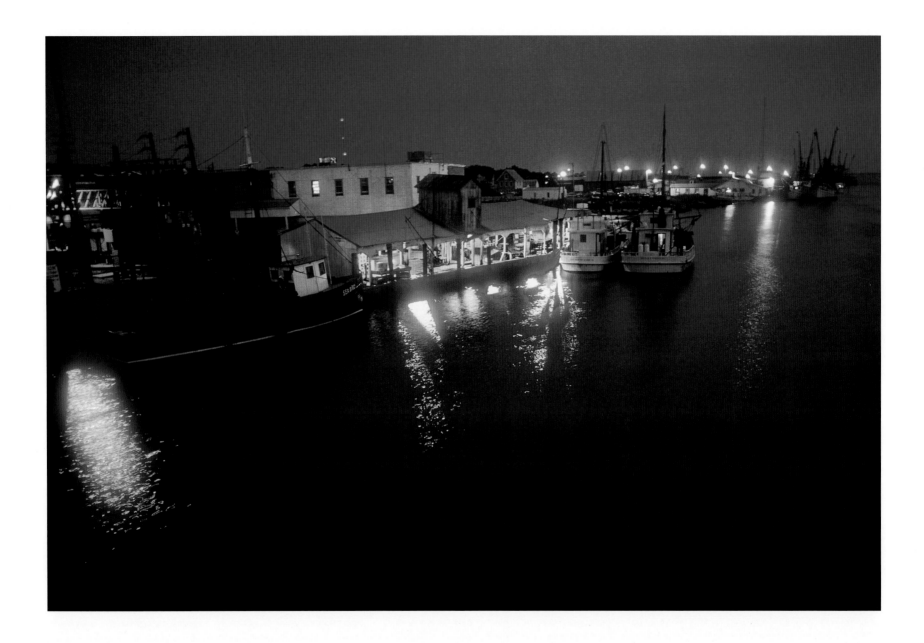

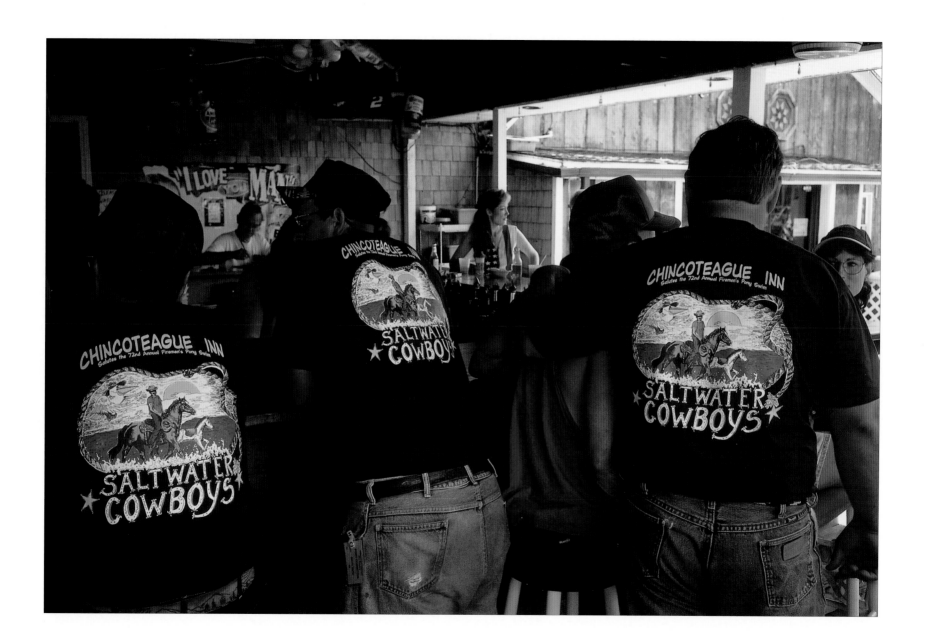

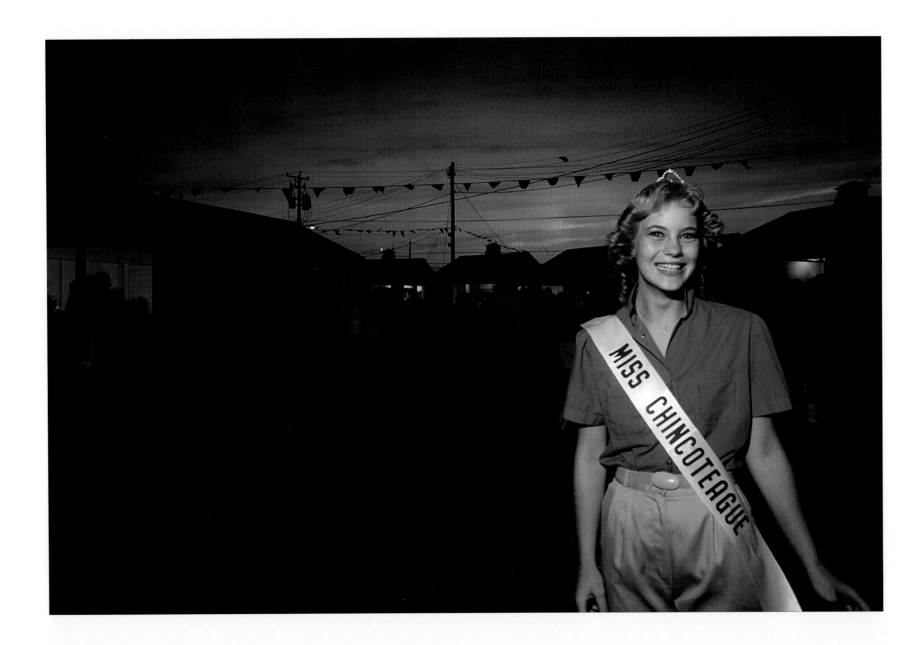

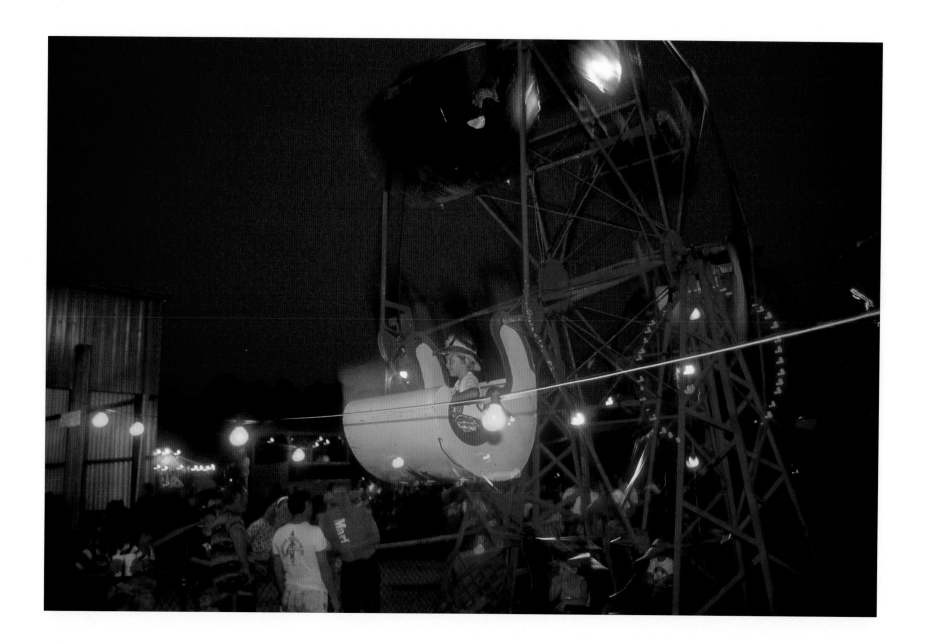

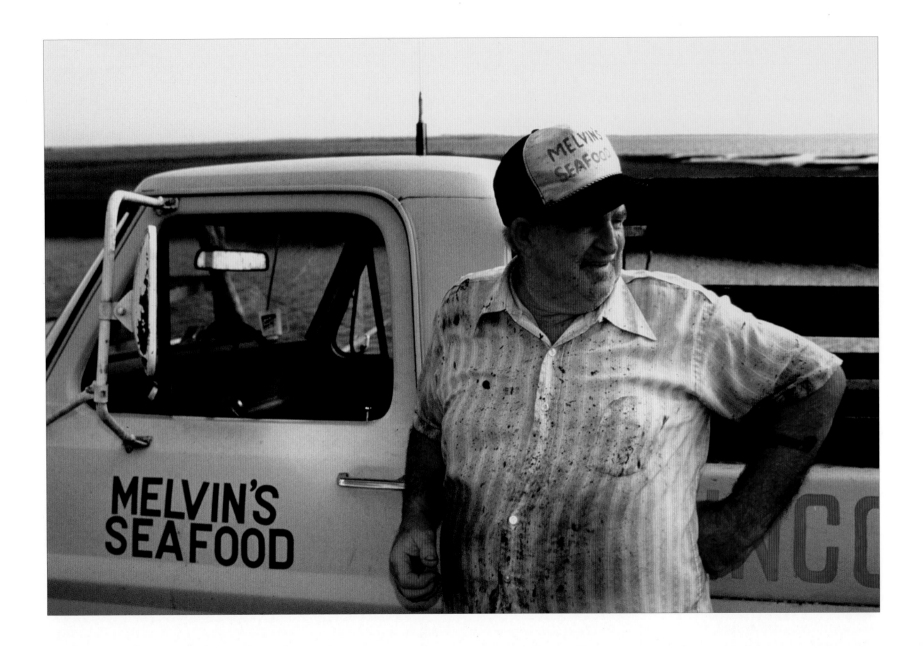

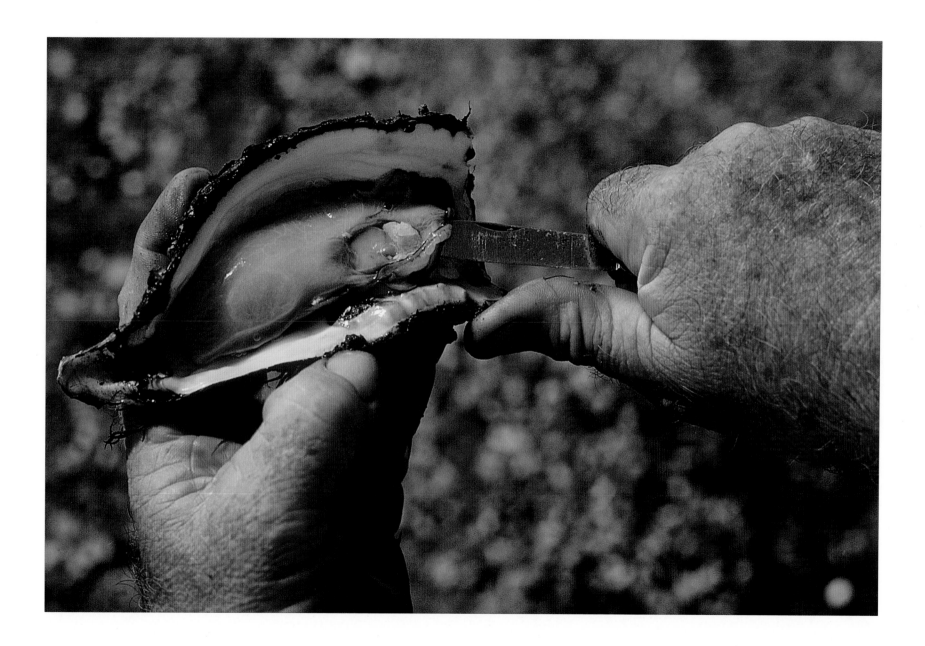

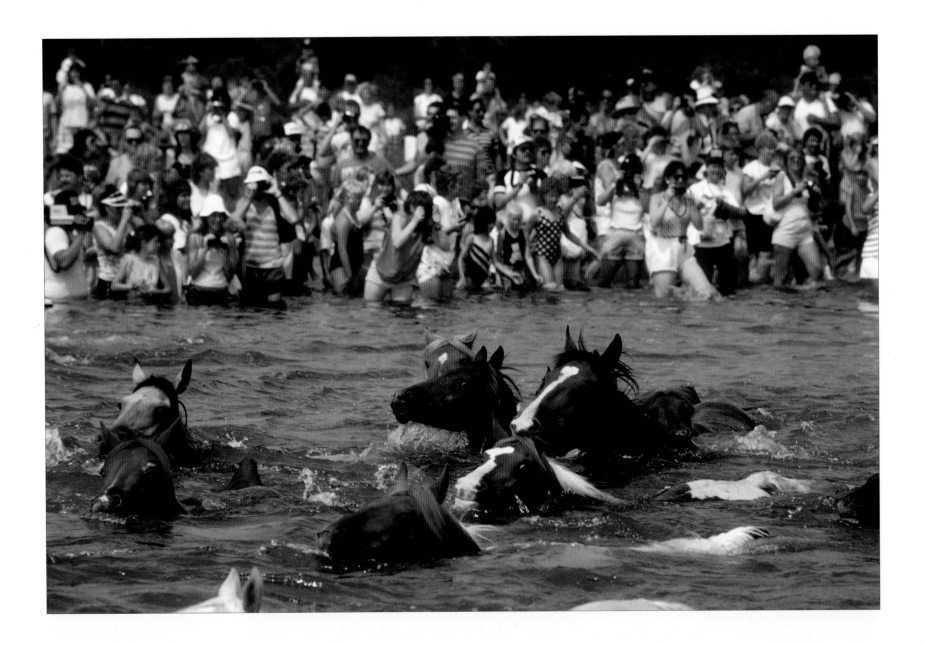

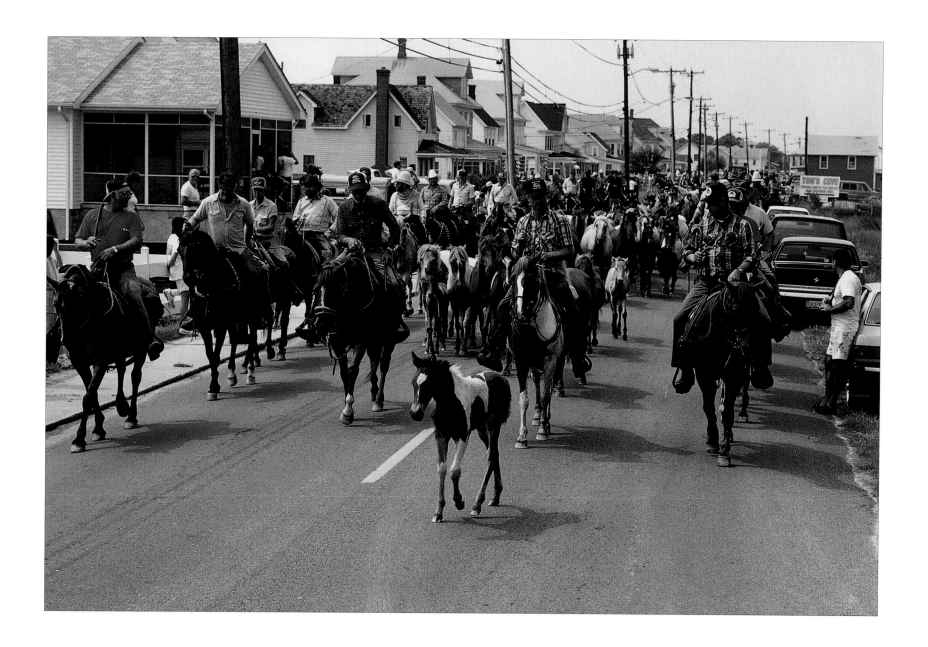

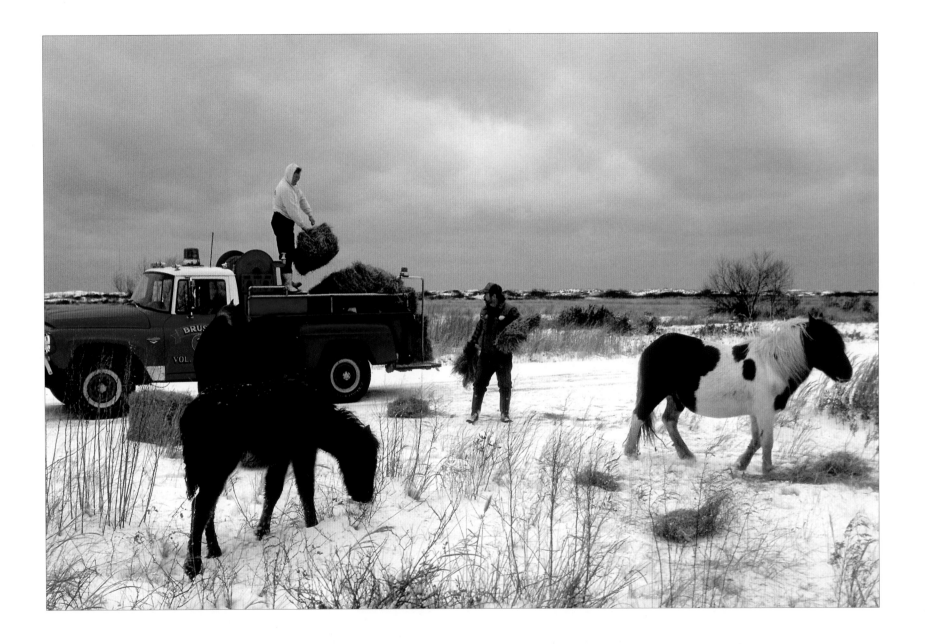

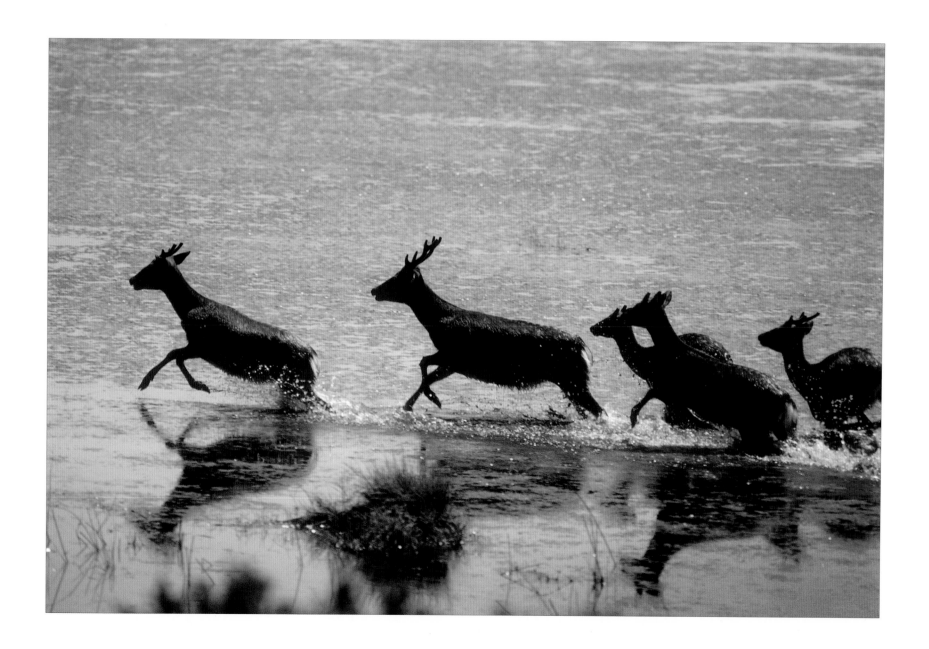

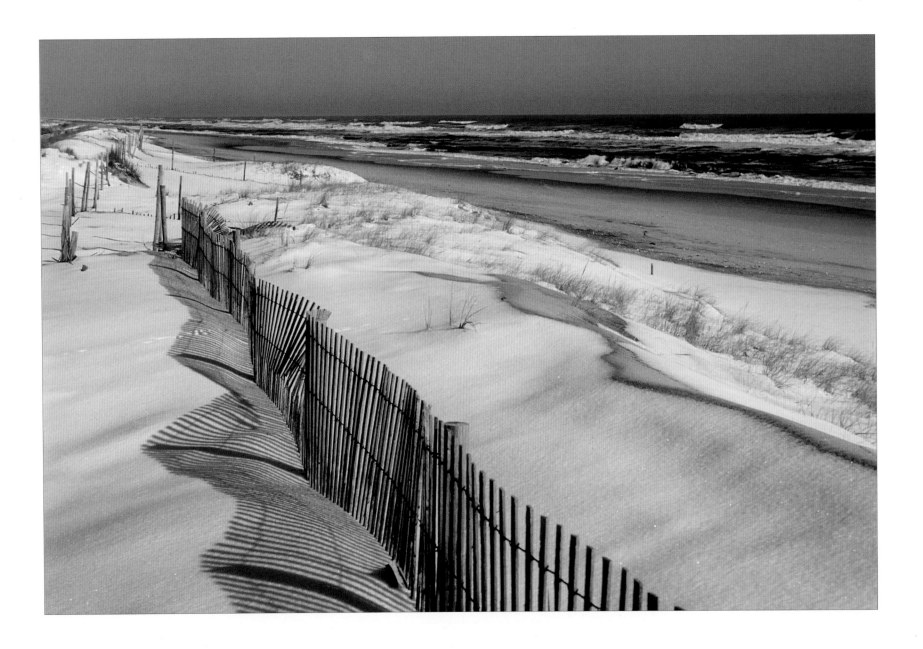

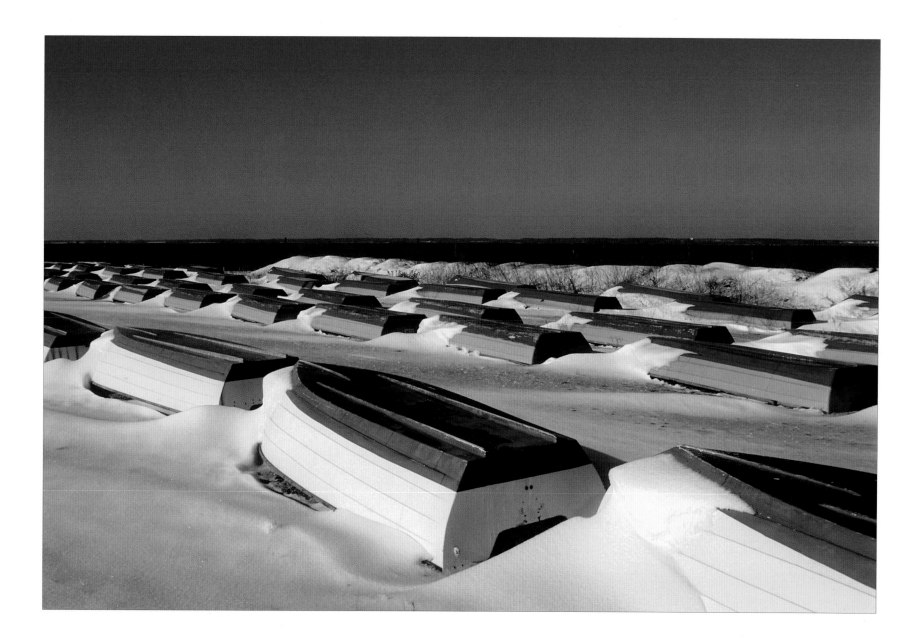

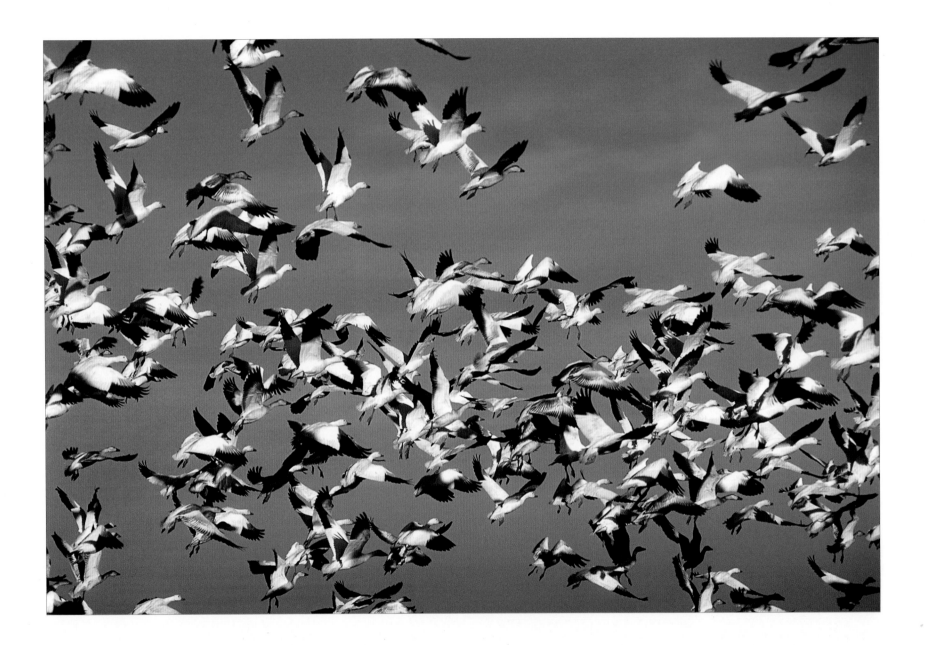

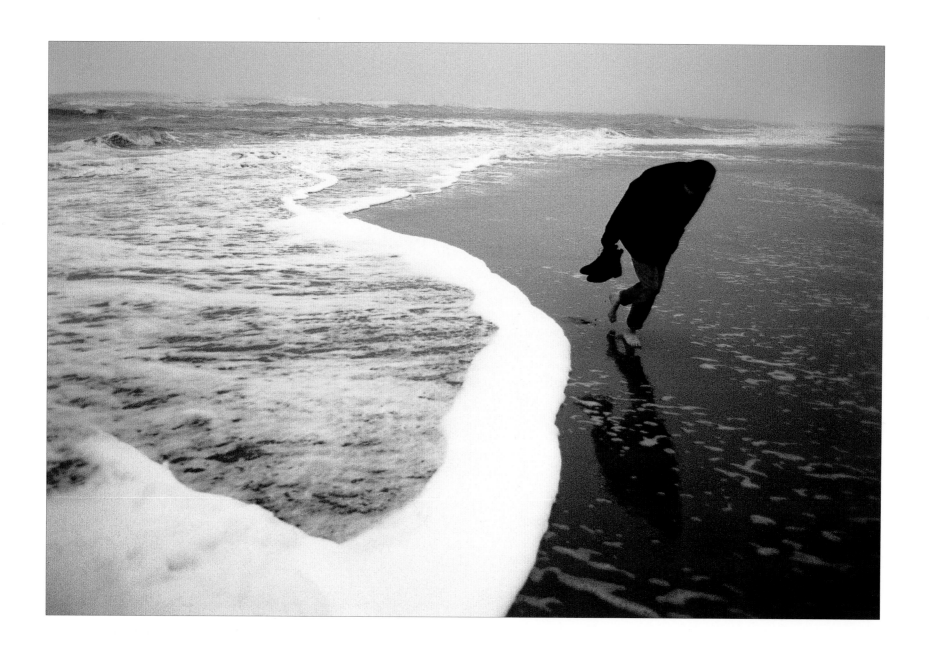

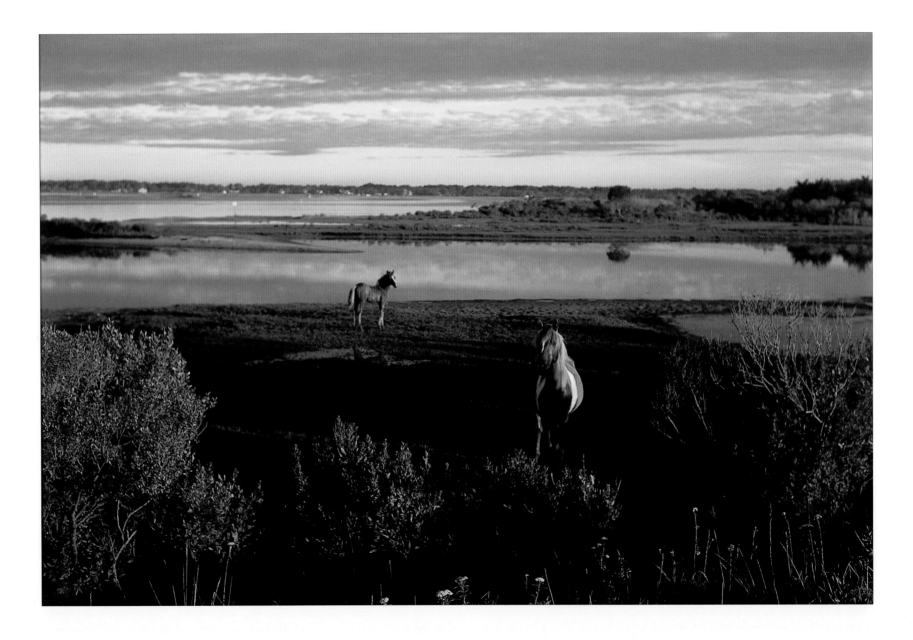

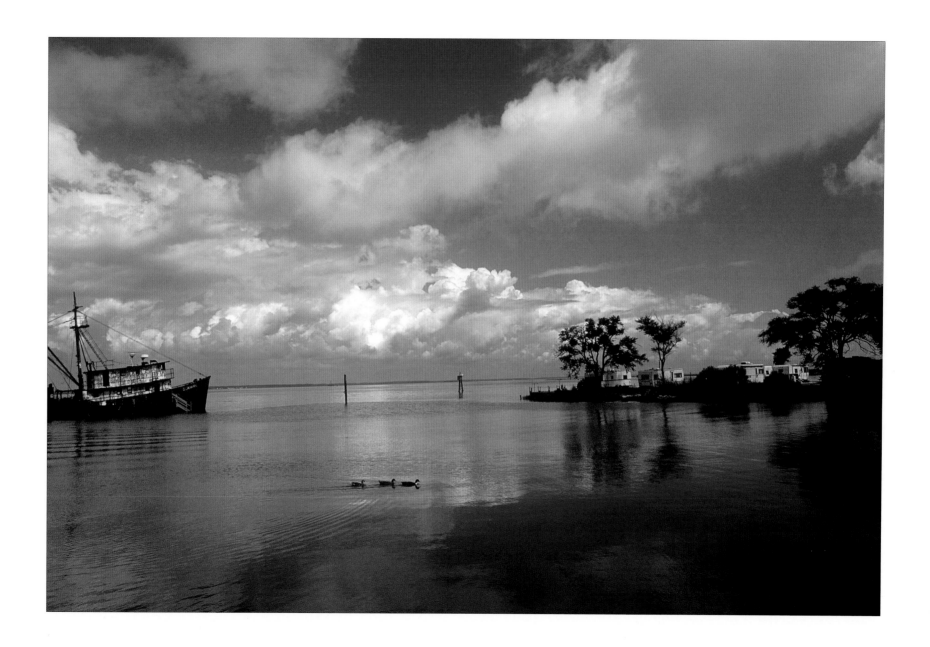

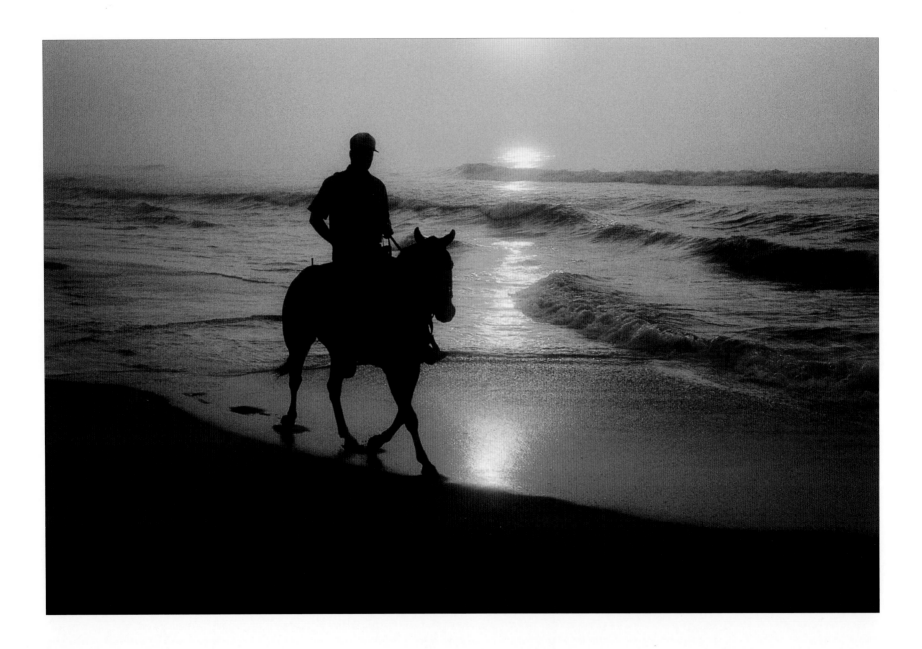

To the memory of those saltwater cowboys and Chincoteague friends who rode their last round-up.

C.P. Burns

Walt Clark

Lee Howard

Bob Melvin

Sewell Thornton

Wilson "Hobby" Tull

Bill Williams

"Where do cowboys go when they die?

Is there a place in the sweet bye and bye...

Where the water is sweet and the grass is green

and there ain't a cloud in the sky...."

from *Where Do Cowboys Go When They Die/Reincarnation*, Michael Martin Murphy/Chick Rains
©1990 Warner Bros. Records Inc.

My introduction to Chincoteague was as a staff photographer for *The Virginian-Pilot,* assigned to cover the Pony Penning in 1972. I had no idea, at that time, that it would become a personal project and would result in a book 30 years later. Each time I returned after that first visit, the fresh smell of salt marshes wafting through the open car windows as I crossed the long causeway, rekindled my inspiration to continue photographing Chincoteague. Several times I drove through snow storms in order to photograph the clean white landscape. I often could not afford a motel room, or there were none available. Fortunately, I was able to rely on the always open door of my gracious friends Pam Barefoot and Jim Green in Onancock. David and Patsy Savage, my 'Chincoteague family' once provided their horse trailer as over night accommodation. Mosquitoes, sunburn and bitter cold winds off the Atlantic sometimes made getting the picture a formidable ordeal.

The older riders still like to tell how my friend, and fellow photographer David Harvey, and I, with full camera gear and overly dressed for the sweltering noon sun of July, ran ahead of the horses the entire two and a half miles along Assateague beach. We even paused long enough to photograph the nude bathers (now outlawed), as horses and ogling riders passed close by.

Years later, on a warm July morning in 1985, I awoke in Chincoteague, drove to the beach, and with the surf breaking over me, photographed the horses being herded down the beach. I next awoke in Moscow, first stop on a mountain climbing expedition to the frozen glaciers of the, then Soviet, Pamirs. This was my first National Geographic Magazine assignment; and the rapid transition, from Chincoteague, to Moscow, to a tent pitched in the numbing cold of the Pamirs 10,000 miles away, was mind boggling.

During a recent Pony Penning, I became hopelessly stuck in the mud, as the horses were crossing a narrow ditch after the channel swim. Just like in the movies, a quick thinking cowboy, Rob White, charged into the thundering herd, reached down from his horse and pulled me up out of harms way. My shoes are still under that black, sucking mud.

This unique little island called Chincoteague is a genuine parcel of true Americana. It has provided a rich life experience and will always hold a warm place in my heart. There are no captions with the photographs. I hope that they speak for themselves; but, if you should wonder or question, then just ask a native Chincoteager. They'll have an answer for you, and you just might make a new friend.

– *Medford Taylor, March 31, 2002*

Photograph on page 17 © The National Georgraphic Society/Medford Taylor

First printing, June 2002

Library of Congress Control Number 2002105186

Library of Congress Cataloging-in-Publication Data

Taylor, Medford
Saltwater Cowboys: a Photographic Essay of Chincoteague Island

ISBN 1-892538-04-0

Published by The Oaklea Press

Book design © Jessica Welton Siddall

Images are available for licensing through National Geographic Image Collection, Images@NGS.org

Books may be purchased directly from the publisher

Printed in the Peoples Republic of China

Acknowledgments:
I am most grateful to the following individuals for their support in countless ways:
Especially all those who appear in the photographs. My friends Sam Able, Pam Barefoot and Jim Green, Brent Cavedo, David Harvey, Bob Jones, Maura Mulvihill, David and Patsy Savage, Elena Siddall, Roe Terry, Robert Young. Jessica Welton Siddall who labored with me over every page. At Mobility, Inc. Mark Chase. At Oaklea Press, Jim Johns, John Gotschalk and Steve Martin, who had the vision to see the book and the courage to publish it.